BORN AGAIN

BY
CLINT MCCOWAN

Copyright © 2016 by Clint McCowan

All rights reserved. This book or any portion thereof may not be reproduced or used in any manner whatsoever without the express written permission of the publisher except for the use of brief quotations in a book review or scholarly journal.

First Printing: 2016

ISBN 978-1-326-81163-1

Clint McCowan
Fischmattstrasse 2
6315 Oberageri
Switzerland

Ordering Information:
Special discounts are available on quantity purchases by corporations, associations, educators, and others. For details, contact the publisher at the above listed address.

U.S. trade bookstores and wholesalers:
Please contact Clint McCowan
Tel: +41 41 750 0188
Email chmccowan@gmail.com

Born Again

For Ben

Verily, verily, I say unto thee, Except a man be born again, he cannot see the kingdom of God. - John 3:3

A Novel

He that believeth on the Son had everlasting life: and he that believeth not the Son shall not see life; but the wrath of God abideth on him. – John 3:36

1.

Clara swore as she fumbled with her seatbelt. 'Jesus Christ! It shouldn't be this hard,' she spat frustrated. Sweat trickled down her back. Her palms were clammy. She clutched the steering wheel with her right hand and pried the seatbelt loose with her left. A lock of her amber hair fell over her right eye. 'Forgive me Peter,' she said to a fresh wave of convulsive sobs. She pressed the accelerator. The family sedan sped forward as it climbed the hill. Clara spotted the opening in the distance, a small bit of highway without a protective guardrail. She looked into the rearview mirror to check behind her. The road was empty. She

Born Again

steered the vehicle carefully to the approaching gateway on the opposite side of the road. 'I'm so sorry Hyrum,' she cried. 'Mom's so sorry.'

As the car alit into the void below, Clara cried, 'Oh God!' She freed her hands from the wheel, and her eyes squeezed shut. For a few seconds she felt light and unburdened as she hurled toward the bliss of nonexistence.

It was a car wreck that blistering July afternoon that killed Clara Poulley. Everyone knew that. What kept the people of Butte talking for years after her death was just why the fatal event happened. According to the gossip around town, Sheriff Banes said that Clara had told her husband Peter that she was going out to 'get groceries'. Instead, she had driven her family's sedan 'like a banshee straight off a large escarpment on Highway 89 north of town for no discernable reason.' According to Banes, there were no witnesses or 'signs of swervin', brakin', or other distress.' The most telltale detail of the incident, he said, was that, 'the little lady wasn't even wearing a seatbelt.' The sheriff was shaken and incredulous. He asked Peter, 'Do you know why she'd do something like that?'

Weeks before her suicide, Clara had told Peter that she had, 'grown tired of living on fringe.' The fact that she was an outsider, a Californian who wore odd clothing and created eccentric art made folks in Butte wary. 'Don't let it get you down Love,' Peter responded, trying to diffuse her angst. 'The good people here are so isolated. Their incestuous gossip is bound to occasionally focus on you.'

'Is that supposed to make me feel better?'

'The truth is that they're just jealous.'

'What? Jealous? Jealous that I'm not a Mormon? Jealous that I've not taken my husband's name? Jealous that I'm not Mrs. Peter James or Sister James? I'm sorry Peter, but people aren't jealous

A Novel

of me!' she said, frustrated. 'I'm a heathen bride. Unlike you, I'll always be an outsider in Utah.'

She paused and looked out the kitchen window at the landscape of red rocks. 'If it weren't for the redemptive features of my life – you, Hyrum, the desert landscape, and my art, I don't know if I could do this,' she said, shaking her head. 'Those anxiety medications make me feel dull and uninspired. I feel worn down.'

Peter rubbed her back and listened. 'You know, I both admire and resent you,' she carried on, looking over her shoulder. 'I don't know how you maintain your detached outlook.'

'My books and the college help,' he replied.

'I get that, but why am I so sensitive? Why am I not strong enough to look above it?'

'It's part of what I love about you,' he said, squeezing her arm and drawing her to him.

'You know, we could always leave Utah,' he posited.

She drew back a wisp of her auburn hair. 'Look Peter, if I can't be happy in this beautiful place, where can I be happy?'

After Clara's death the community rallied together to look after the temporal needs of Peter and his son Hyrum. The women's Relief Society organized evening meals to be brought to the home for no less than a year. Peter purchased two large chest freezers for the basement to accommodate the abundance of casseroles. For him, the piled vessels of aluminum-wrapped foodstuffs came to resemble monuments of sadness. They spoke of the transitory glisten of life and love.

The elders of the church made weekly visits to the house to look after the well being of father and son. They were troubled by Peter's secular and professorial habits and were particularly concerned by the fact that couple's soon to be eight-year-old son seemed to be taking up his father's peculiar and reclusive ways. For young Hyrum the elder's visits were a strong reminder of the

events and atmosphere surrounding his mother's death. His escape was to curl up at the end of the sofa and read while the suited men sat hunched forward next to him and spoke in quiet sympathetic tones to his father in the chair opposite. They smelt of polyester and aftershave.

On one such visit Hyrum realized that the hushed conversation had meandered to his upcoming birthday and impending baptism. He feigned reading his book and listened intently to the discreet exchange. Peter said to the elders, 'While I appreciate my heritage and take Hyrum to Sunday meetings when I can, I'm not a true believer in Mormonism.' The confession seemed to come as nothing new to the elders. It was a revelation to Hyrum. Just that morning he had sat in Sunday school with the other boys and girls and had been asked to read John 3:36 aloud. As a quiet, sincere, and cerebral child, he had subsequently thought all day about God's wrath and how to be good so that he could achieve everlasting life. He made careful mental lists of both immediate and more long-term 'goodness objectives'. His list included a dozen simple tasks such as washing dishes and vacuuming around the house. It also included a handful of more elaborate goals like committing to daily scripture study, reflective prayer, and making his dad happy again.

'So, who will be baptizing Hyrum?' the chubby elder whispered. Peter winced at this and with his head resting in his right hand he glanced at his boy with humiliation. Hyrum's eyes darted back to his book, and his face flushed. The elder proposed that Peter's brother Bud should be asked to step in for the task. Peter nodded his head in agreement. Hyrum's head spun. His thoughts drifted back to the Biblical verse from John. He was confused by the concepts of belief and redemption and felt scared at the thought of being baptized. He thought, 'what does it mean to have one's sins washed away? Where do they go? Do they go

A Novel

down the drain with the water as the font empties? Is there some big tank holding sinful water under the church? What does a sin look like? Will the wrath of God come down upon me if I sin after I'm baptized?' He felt uncomfortable with the idea of doing something so personal in front of all the people at the church. It then dawned on him that his mother had not been baptized before she died. 'Where was she?' he thought. 'Was the wrath of God upon her? Was she in the tank of sinful water under the church?'

As Peter put Hyrum to bed that night, he could see Clara's sensitivity and angst in his son. Hyrum relayed his thoughts and reservations about baptism to his father. Peter took a moment to compose himself, reached for Hyrum's hand, and responded that baptism was largely symbolic in nature and that it was a part of their Mormon culture. Symbols and culture were abstract and challenging concepts for Hyrum. He held back his tears, nodded approvingly, and looked at his father's large trembling hand. The hand looked older and more fragile than he remembered. 'Dad,' Hyrum interrupted, 'I was thinking that Uncle Bud could baptize me twice, one time for me and one time for Mom. Then she can be saved too.'

Born Again

We speak that we do know, and testify that we have seen; and ye receive not our witness. – John 3:11

2.

It was a cold October Sunday morning when Hyrum drove north on Highway 89. The heater in his rusted '60 Chevy C10 truck gave just enough warmth to thaw his boots. He didn't much notice the chill. After living for some three decades in this dry Utah country, the passing patchwork of irrigated valley farms, solitary cottonwoods, and small clustered settlements gave him the distinct warmth of colloquial familiarity. Looking into the foothills of Juniper Mountain, he observed the outcroppings of tangerine limestone, stands of autumn maple, and ochre Manzanita. He felt the peculiar order and chaos of nature's hand and observed how the high desert made the heavens profoundly blue.

A Novel

While the good folk of Butte found their weekly refuge in church services, Hyrum generally sought his Sunday calm in the surrounding canyon wilderness. In contrast to the colorful landscape of the high desert, the Sunday meetings were predictably monotonous and overly ordered. While the LeByron brothers, local drunks that they were, provided occasional moments of mumbled inebriated humor and uncanny truth, the bulk of the meetings were stiflingly mundane.

Only six weeks ago Cimarron LeByron stood mid-meeting and denounced Elder Smith, a newly sustained church leader and local insurance salesman. LeByron attacked Smith for not paying out an accident insurance claim that involved a backhoe and LeByron's left leg. As the drunk was escorted out of the building by his brother Merle and several men in the congregation, he pleaded with Smith. 'Can't you see? I can't work anymore because of this injury.' Elder Smith was perched next to the Bishop at the pulpit. Smith whispered with the bishop and shook his head in disapproval. The congregation gasped when they heard the inebriate yell 'Elder Swindler' and 'Crooked Smith' from the foyer. Sitting in the pew toward the back of the church, Hyrum raised his hands to applaud LeByron. He stopped short when he noticed the scowls on the faces of the church folk around him.

LeByron was easy prey for the predatory Smith. The Elder had recently been named 'Employee of the Year' for his salesman's status of having the lowest payout on insurance claims in the state. Smith cleverly flanked his honorary Good Neighbor Insurance company plaque with two admirable sets of deer antlers in his cedar-planked office. He could often be found sitting behind his robust oak desk, drawing his client's attention to the antlers and, inevitably, the plaque, with stories of the hunt. For Smith, LeByron's leg was yet another boney contribution to his

Born Again

comprehensive trophy case. For LeByron the antlers and plaque became cruel reminders of the Elder's jackal-like prowess.

It was back in January when folks were fired up about New Year's goals and resolutions that the portly, balding, and generally sweaty Bishop announced from the pulpit that for the upcoming year all meetings would focus on 'obedience to the Lord and His church.' Hyrum took this announcement personally. For years Bishop Hafen had warned him against what he called the 'twin temptations of intellectualism and clever-headedness.' Liberal thought and literature that cast the history and policies of the church in dark places was deemed non-faith promoting, toxic to the soul, and was to be avoided like Eve's forbidden fruit. At their last personal interview Hafen reprimanded Hyrum for reading subversive material and warned him about 'stirring the pot' by posing 'odd questions in the elders quorum.'

'No more questions about the virgin birth, them missing Golden Plates, or Jews in ancient America,' the Bishop said as he raised his voice, 'and no more about polygamy, them gays, trans-what-evers, or the position of women in the church, Hyrum, and I mean it.'

'But do we genuinely believe the Church about these things?' Hyrum replied.

'Of course we do,' the Bishop shot back. 'What's happened to your faith?'

'I don't know,' said Hyrum, 'a lot of things just don't seem to add up. Why, for example, shouldn't women be able to hold the priesthood?'

'Don't be ridiculous!' Hafen said, putting his head in his hands. 'Giving women the priesthood would be unnatural. It'd upset the whole order of things. It's not what God wants.'

'But isn't that what was said before African Americans got the priesthood?' Hyrum replied.

A Novel

'Don't go bringing that up, Hyrum. That's a different and unique case. What would we men do if women had the priesthood? You ever think about that?'

'I'm not threatened by that. We'd get on as we always have. It's just that men and women might finally have equality in the church. I just don't think one's gender ought to interfere with one's opportunities.'

'That's a matter for God and the prophet to decide.'

'But if the prophet is a conservative old white man, what are the chances that …'

'That's too far, Hyrum' the Bishop said raising his voice and pointing at Hyrum. 'That's too far. That's enough of that.'

Hyrum saw that he had reached a dead end on the topic but decided to press on. 'I've got another question.'

'What is it?'

'Are you convinced that Joseph Smith could really translate those Egyptian hieroglyphs? I read a book by a respected Egyptologist that showed that the *Book of Abraham* translation was a comprehensive farce. Joseph couldn't read those hieroglyphs. He only had a third grade education.'

'How dare you blaspheme the prophet!' the Bishop thundered.

'But I don't understand why we can't talk about these things?'

'Because it's unholy, that's why! The prophet was a seer and revelator.'

'But his translation was completely wrong.'

'It's the translation that God wanted!'

'But how do we know that?'

'We know it because we're faithful and faithful is what you better be if you don't want yourself thrown out of this church.'

'I think it is best that I leave, Bishop,' Hyrum said getting up.

Born Again

'Wait, wait, Hyrum,' the Bishop said raising his hand slowly, wiping his dripping brow, and calming himself, 'we've got another matter to discuss. What about your daughter, Clara?'

'What about her?' Hyrum retorted.

'She's just turned eight and is due to be baptized soon,' the Bishop said measuredly, 'and you're supposed to be baptizing her.'

Hyrum looked at the floor and ran his hand over his mouth. His ex-wife Jesse had been hounding him about the impending baptism for months. She had even got Elder Smith, to whom she was newly engaged, to try to talk 'man to man' with Hyrum about the situation. The conversation went poorly and ended with Hyrum blasting Smith for his meddling.

'You've got one month to repent for your prideful mind and to come to your senses, Hyrum,' the Bishop warned, 'Otherwise, I'll ask your uncle Bud or Smith to do it.'

'Smith? Why the hell would you ask Smith to do it? Clara's my daughter, not his.'

'Watch your tongue in the Lord's house Hyrum!' the Bishop said rolling his eyes and placing his hand over his forehead. 'Look, you leave me very few options. Jesse's father Herb is wheelchair bound. He can't do it. Smith is an upstanding man in the community. He's worthy to do the baptism, and he'll be Clara's stepfather before too long.'

'Good Lord,' Hyrum replied shaking his head, 'this is all getting out of hand.'

'Hyrum, if you'd better attend to your spiritual duties you wouldn't be in this trouble. One month,' the Bishop said again.

'Let me give it some thought,' Hyrum said as he got up to leave.

With the Bishop's final words resonating in his mind, Hyrum realized a month had passed since their last meeting. He hadn't been back to church since, and he didn't have any plans to do so in

A Novel

the foreseeable future. As Lee's Junction drew into sight he was compelled to shift his focus from the Bishop's ultimatum to a more pressing problem. He stirred nervously. Lee's was the only liquor, gas, and convenience store in the whole county.

One had to be careful about one's doings at Lee's. Word of a local's purchase of coffee or alcohol could spread like a summer wildfire. Hyrum didn't want to further damage his already battered reputation, and he also knew that purchases at Lee's could jeopardize his teaching position at the local high school.

His most immediate concern was which of the Lee's employee would be on shift. Only a week before he had driven-by several times before discerning the maroon Buick LaSabre parked out back and the large matronly figure of Josephine Biggs inside. He knew better than to throw himself into Josephine's beehive of gossip and had driven off.

Josephine was a woman known countywide for her fair-winning apple pies and her hairstylist's ability to match her own graying head to the color of her car. Her husband Walter Biggs was a short, thin man who busied himself in retirement by crafting wood sculptures of desert animals in his back yard shed to avoid the regular and demoralizing nagging of his wife. Josephine fashioned herself, along with the elders of the church, as part of the moral guardianship of the community. While folks knew Josephine's piousness was feigned, they feared her venomous gossip so much that they showed her a deep and singular respect that put her on par with the Bishop. It was in this elevated position that Josephine worked two shifts a week at Lee's. She believed it was her duty to stand sentinel-like over purchases of alcohol and coffee. Even the LeByron brothers were forced into sobriety when Josephine was on shift.

The clerk Hyrum hoped for was Emma, a quiet, slim, and natural looking Navajo woman. As a disinterested outsider in the

Born Again

community, folks knew that with Emma knowledge of their purchases would be safe. The Californian owners of the store had taken note of the doubled daily sales when Emma worked her shifts. When they pushed her to move from part-time to forty hours a week, she couldn't refuse. She needed the money.

Emma lived in a trailer with her fourteen-year-old son Sam in the nearby settlement of Meadow. She moved to the area a year ago to attend literature courses at the local community college. She wrote compulsively about her life's little observations in small black spiral notebooks. These she showed to no one. Emma had dreams of becoming a writer and worked doggedly in her studies. Rumor was she fled the reservation to escape her abusive alcoholic husband.

And so it was that as Hyrum did his first Sunday sortie past Lee's, he was relieved to see Emma's International truck parked next to the large propane tank around the side of the squat brown brick building. He pulled cautiously in next to the fuel pump, put a half dozen gallons into the truck, and walked toward the front door of the store.

Things were generally quiet at Lee's on Sunday. With the community at church, most customers were either retirees driving large motor homes or German tourists in small cars on their way to the local national parks. Hyrum paused at the door and peered in through the glass. He saw Emma helping an elderly couple at the counter. He took a last glance around the premises and entered.

Making his way to the small liquor section at the rear of the store Hyrum gazed at the deer heads on the wall. As awkwardly poised shells of their former selves, the animals looked glossy and hollow. He thought of LeByron's boney leg, hanging like one of the deer racks in the Elder's insurance office and shook his head. Grabbing packs of sunflower seeds and beef jerky, Hyrum stopped

A Novel

briefly for the free Styrofoam cup of coffee that came with the purchase of gas. He drank the lukewarm watered-down liquid in two gulps. He'd grown to like the bitter flavor and had recently come to understand just what his uncle Bud meant when he regularly said, much to Aunt Laverne's dismay, that 'coffee was just one more proof that God exists.' Hyrum then moved toward the area of the store demarcated by the pink neon 'liquor' sign. The letters were written in a fancy cursive that reminded him of Las Vegas. He picked up a six-pack of canned beer and a bottle of whiskey.

Arms full, he approached the counter where Emma was busy explaining the location of a local landmark to the retirees. His anxiety heightened by the caffeine, Hyrum shifted back and forth, nearly dropping the whiskey. He kept a nervous eye out the window for familiar cars and noticed again the sign announcing 'Lee's Junction'. Held aloft by a fifty-foot pole, the enormous sign dwarfed the squat building. He furrowed his brow.

Sensing Hyrum's angst, Emma craned her neck to look beyond the retirees and motioned Hyrum to the till. He mumbled an apology, moved forward, and clumsily dropped the items on the counter. Hyrum noticed the way she handled the sundries with her slender hands. He examined her high cheekbones, slightly crooked teeth, and long dense black hair. 'Thank you Emma,' he said ashamed.

'For what?' she replied.

He turned his mouth to the side and began to mumble again when she interrupted, leaned forward, and whispered, 'you wouldn't believe it if I told you – who comes here to buy liquor.' He grinned, removed his cowboy hat, and ran his hand through his graying brown hair. He leaned forward and whispered with a smile, 'Well isn't it an honor. To be counted amongst the sinners.' Emma took note of how the mark left by the hat accentuated

Born Again

Hyrum's graying cowlick on the left side of his forehead. She chuckled, wished him a heartfelt good day, and reached under the counter for her spiral notebook.

Relieved to have his purchases concealed in a brown paper sack, he paid up, got in his truck, and sped away westwards toward Juniper Mountain. As Lee's disappeared in the rearview mirror, he realized his heart was still racing. He laughed at himself, opened a can of Utah beer, and took a long and thoughtful swallow. He relaxed and felt a spark of redemption.

A Novel

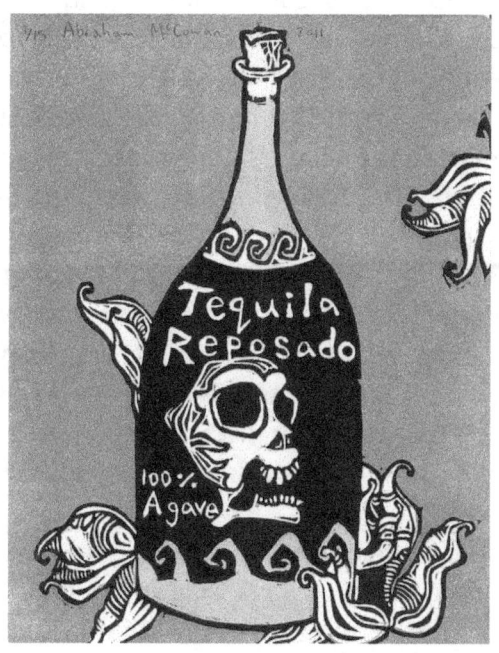

How can a man be born when he is old?
Can he enter the second time into his mother's womb,
and be born? - John 3:4

3.

While idle talk amongst the men of Butte generally centered on trucks, tools, and farming, their true passion was hunting. The autumn deer harvest, the most popular of the seasonal hunts, was much more than just an annual activity. The deer hunt chronicled a boy's ascent into manhood. A man was not a man until he had scouted and shot his first deer. Hyrum couldn't help but to see this peculiar truth when his father annually quipped that the deer hunt was 'the Mormon equivalent of the Jewish Bar Mitzvah.'

Born Again

 For the last two seasons one mythical mule deer had the power to quiet boisterous conversations and draw men close together to speak in reverent tones. This colossal trophy buck had consumed the minds of every coherent male in the community. Seen only by two trustworthy locals, the elk-sized animal had somehow outsmarted the hunters and eluded being shot.

 When eight months had gone by without a sighting, some speculated the deer had gone nocturnal or had left the area entirely. That was until Levi Heber, the bank manager's teenaged son, saw the fabled buck flash across his binoculars when scouting deer from an undisclosed vantage point on Juniper Mountain. With less than a week to go until the opening day of the hunt, his report confirming that the animal was indeed in the area set off a flurry of activity. Even the old timers couldn't recall a more anticipated opener.

 Like the other males in Butte, Hyrum had dreamt about the buck on several occasions. Always vivid in his dreams, the animal would emerge from the scrub oak shrouded in fog and reveal its noble self. Troublingly, the deer's head would then slowly transform into the face of his ex-wife Jesse. This transformation so disturbed Hyrum that he would wake in a panic before dozing off again for a fitful night of sleep. Following the dreams, he'd spend the next morning pondering the reoccurring pattern. He eventually chalked it up to the stress of the divorce and the ongoing anxiety surrounding his ex-wife Jesse. Nocturnal nuisance aside, Hyrum decided to throw his hat in the ring with the rest of the hunters to take down the trophy buck.

 Hyrum's special hunting spot was less than five miles from Lee's Junction. He had half chosen the location because of its proximity to the offerings at Lee's and half because of the distinctive and narrow gorge he had discovered there one evening

A Novel

after a frustrating day of teaching Shakespeare to his grade eleven students.

With Shakespeare again on his mind Hyrum left the asphalt and turned north on a rough and winding logging road. He opened another can of beer and rolled down the window to take in the sharp and sweet morning smells of the old growth Ponderosa and Juniper. Perhaps it was the scent of the canyons that he loved the most. The pungent, medicinal aroma of Juniper berries filled his nostrils and brought his mind back to memories of his childhood experiences on the hunt with his granddad.

Pulling off of the dirt road at a discreet turn out and getting out of the truck, Hyrum hiked the half-mile through the scrub oak, beer in hand, toward the canyon. He had only recently begun to dabble in drinking. With the exception of an occasional drink when camping with friends in high school, Hyrum had followed the church's 'Word of Wisdom' and abstained from alcohol, coffee, and tea. He saw his recent venture in the drink for what it was, an outlet, an anxiety-reducer, and, at times, a simple juvenile rebellion against the teachings of the church. He didn't take it all too seriously. He also knew that a number of early church leaders, including the founder Joseph, had dabbled in the drink. His direct ancestors, the early pioneers in southern Utah, had made the desert blossom with their grapes and enjoyed the beauty of wine. Local lore about the lost days of Mormon wine making had it that the harsh conditions of the high desert put a 'blessed strain' on the vines. This struggle of the vine produced a fine wine, like 'honey from the heavens,' the locals alleged.

He arrived at the canyon, retrieved the whiskey from his backpack, and took a long drink from the bottle. Following his granddad's rule of thumb, Hyrum looked at the ground. 'Folks spend their lives looking out ahead when they can usually find what they are aiming for right under their noses,' Granddad used

Born Again

to say. Hyrum identified two deer paths in the immediate area as well as a worn pine needle bed on the forest floor. After confirming that no other hunters had interfered with the site, he unstrapped his deer camera from a nearby Ponderosa and viewed its takings.

'Damn coyotes,' he muttered, looking at the first image and taking another long drink. The next pictures turned up a meddling doe that apparently took pleasure applying her wet nose straight onto the camera lens. 'Oh, what?' he uttered as he flipped the camera over and examined the smeared lens. Wiping it clean with the sleeve of his Carhartt jacket while cursing and taking another drink, Hyrum steadied himself against the Ponderosa when he saw the subsequent photo. There, emerging from the forest in the fog, in all of its dream-like grandeur, was the giant buck. He counted a dozen or more points on the antlers while staring at the image with trembling hands. He realized that the Heber boy had not exaggerated, as some had suspected, about the animal's enormous size.

With its stately head, large brown eyes, and massive antlers turned toward the lens, Hyrum began to struggle in his drunken state to discern dream from reality. Closing his eyes, he could see Jesse emerge again from the head of the deer. Shaken, he sat on the ground, camera in one hand and bottle in the other, and leaned back against the tree. He recalled the passage from Shakespeare when Hamlet says, 'what a piece of work is a man, how noble in reason, how infinite in faculties, in form and moving how express and admirable . . . The beauty of the world, the paragon of animals.' He looked around the canyon and blurted out, 'Am I the paragon of animals?' Gazing at the camera again and taking another drink, Hyrum turned the camera screen outwards to show the noble beast to the trees, scrub, soil, and sky

A Novel

in the intimate canyon view in front of him. He said to the canyon, 'No, no, Mr. Shakespeare, animal is nobler than man. See? See?'

Hyrum laid the camera down, slouched over, and drifted off into a drunken sleep. He dreamt about the early days of his courtship with Jesse Jessop in high school. While he couldn't pinpoint exactly why she became the object of his desire, he liked her big brown eyes, bleached blond hair, sun kissed face, and the way her feminine curves looked in Wrangler jeans. Perhaps most of all, Jesse was the rodeo queen. The way she rode her horse quieted all onlookers, young and old, male and female. She was the trophy of the community; the desired prize of a generation.

When Jesse became pregnant at nineteen, the scandalized young couple carefully considered their options. Their decision to marry was driven less by love and more by expediency. A pregnancy out of wedlock, let alone the act of sex, put sinful types in Butte in religious and social peril. The marriage was difficult from the beginning. The teens hardly knew one another. For Jesse, her brush with social ostracism turned her from a free spirited, risk-taking youth to a severe and devout Mormon wife.

Jesse regularly reproached Hyrum for commuting an hour each way to study English literature at the university, for being unemployed, and for taking one student loan after another. 'What do all those books have to do with us?' she yelled across their small, scantily furnished apartment. Hyrum sat up and readied himself for the familiar argument. He put his copy of Chaucer down amongst the other books and papers on the desk in front of him and shuffled things around. 'It must be nice sitting around reading all day when everyone else works,' she carried on, curling her hair and getting ready for a shift at the local grocery. 'For heaven's sake Hyrum, you should be ashamed of yourself. I'm pregnant and I...' she trailed off, becoming quiet. He got up, slowly walked across the apartment, and stopped at the bedroom

Born Again

doorway. Jesse sat on the edge of the bed with her head in her hands. 'Real men have jobs Hyrum,' she said bluntly. He tried reasoning with her about the value of education, good books, and his plans to become a teacher. This angered her further.

'If your dad hadn't indulged you so much as a child you'd be out there now working like everyone else!' she snapped.

'Look Jesse, don't bring my father into this,' Hyrum replied calmly. 'It wasn't easy raising me on his own.'

Softening her tone somewhat, Jesse replied, 'Thing is, you're turning into him, and I don't like it!'

Hyrum shrugged his shoulders and gazed out the small window. His thoughts focused on his lonely childhood with his father. 'I'm sorry,' he said and turned away, 'I just don't know how else to be.' She got up, wiped her eyes and posed herself in front of the mirror. 'I'm going to work. Make sure the house is clean when I come home.'

In a gesture of charity, Jesse's father Herb offered Hyrum a job at his Ford dealership. When Hyrum politely turned him down, Jesse was incredulous. As their lives became more and more disparate Hyrum delved further into his readings and Jesse found reassurance with her co-workers and the women at church. For social purposes they agreed to continue their cold cohabitation. While the birth of their child, Clara, brought the couple closer together for a short time, they struggled in the years that followed to overcome their differences and expectations of one another.

Some time had gone by before Hyrum woke. Outstretched on the ground with camera and half empty bottle nearby, he examined the canopy of ponderosa and the cloudless desert sky. Crows cawed and his head hurt. He felt a keen desire to urinate. He gathered his scattered belongings and waited to relieve himself until he was back to the truck. 'That buck is mine,' he thought to himself. Realizing that he'd likely be late for Jesse's 5:00pm drop

A Novel

off time for Clara's three-day stay, he sped down the dirt road to his small stone-built house in Butte.

Born Again

Verily, verily, I say to thee, Except a man be born of water and of the Spirit, he cannot enter into the kingdom of God. – John 3:5

4.

Clara liked combing her auburn hair, carrying stones in her pockets, and talking in a low voice. She also liked books and could often be found curled up in a corner of a chair reading. This growing solitary behavior was a concern for Jesse, who saw too much of Hyrum in the child. Just that morning mother and daughter had spent the church service bickering over books that Clara insisted she 'wasn't reading' but continued to make their way back into her lap as if by magic.

For Clara, the weekly visit to her father's house was a welcome respite. She didn't have to mask her incessant reading with decoy dolls like she did at her mom's place. She also looked

A Novel

forward to the evening discussions about the world of books and liked the grown up feeling she had when her dad asked and listened to her opinions about things.

'Hi kiddo,' Hyrum said opening the door to his house. 'Hey, fancy haircut.'

'Hi Dad,' she replied, giving him a quick hug and throwing her backpack on the couch. 'You like it?'

'I do indeed. I've always thought short hair suits you,' he said, messing her hair with his hand.

'Yeah, Mom doesn't like it. She thinks Josephine cut it too short.'

'Really?' Hyrum said, noticing Jesse's car still in front of the house.

'Did you hear? Mom says Josephine's sick,' Clara said, straightening her bangs and climbing into granddad's old red chair with her book.

'Sick? Sick with what?'

Out of the corner of his eye Hyrum saw Jesse waving, motioning him to her truck. He looked back at Clara, turned and walked slowly towards Jesse, knowing what was coming.

'You've not been back to church,' she said, inspecting Hyrum's unshaven face. He didn't reply.

'Bishop Hafen has asked your uncle Bud to baptize Clara,' Jesse continued. 'Doesn't that bother you?'

Looking at the ground, Hyrum mumbled, 'I suppose so.' Glad that Smith wasn't asked to do the job, he paused, looked up, and asked, 'Do you really think Clara needs to be baptized?'

Before giving her a chance to respond he continued, 'I mean she's just turned eight. What big sinning has she done to need to be saved?'

'Don't be ridiculous, Hyrum,' Jesse retorted, 'We all need to be saved.'

Born Again

'Just what do you mean by that, Jesse?' Hyrum asked. 'What are we being saved from?'

'Our sins, Hyrum,' Jesse replied impatiently.

'But what does the death of Jesus all that time ago on the other side of the world have to do with our lives today in Utah?' he asked.

'Jesus was the Son of God, Hyrum. He died to save us. Joseph Smith reestablished His True Church on earth after the Apostasy, and Brigham Young led the Latter-day Saints to Utah after Joseph's martyrdom, and you *know* that. That's what Jesus has to do with Utah. Why can't you understand these simple facts?' she said imploringly.

'Facts?' he asked sincerely. 'How do you *know* all of that?'

'I know it through faith, Hyrum,' Jesse said. 'Aren't you even a Christian anymore?'

'I don't know what I am Jesse. You know I don't like labels.'

'Oh wow, why do you have to be so...'

Cutting her off, he said, 'Have you asked Clara about what she thinks about any of this?'

'She wants you to baptize her, that's what she thinks!' she shot back.

'That's not what I mean,' Hyrum replied calmly. 'Have you asked her *if* she wants to be baptized or *why* she wants to be baptized?'

'Of course I have,' Jesse said, growing more impatient.

'And what did she say?'

'She said 'yes,' that's what she said.'

'But why did she say yes?

'Because she knows it's right,' Jesse said sharply.

'But how does she know baptism is right?'

'Because I've told her it's right! The Bishop told her it's right! Everyone but you has told her it's right!'

A Novel

She turned and stared straight ahead through the dusty windshield, waiting for Hyrum's response.

Taking a look around the broad, quiet street, Hyrum replied, 'But how does everyone around here know it's right?'

'Because that's what we were taught!' she said, still staring ahead.

'But don't you see the problem. Just because people are told something, it doesn't mean it's . . .'

'It's what God wants, Hyrum!' she said, turning towards him. 'It's in the Holy Scriptures! The prophets have told us! Even Jesus himself was baptized!'

'But Jesse, how do we really know what God wants? Has God ever spoken to you?'

Exasperated, Jesse covered her face with her hands and shook her head.

'What's wrong with you? Why can't you just be normal like everyone else?'

'But Jesse, don't you think that what is 'normal' here is unusual in places not so far from here?'

'You're like a damn child, Hyrum. Why do you have to ask so many questions? You know, I always knew it would turn out like this. Can't you see? This is what wrecked our marriage.'

'Oh Jesse, come on. We were just kids who were forced to get married because you were pregnant.'

She looked forward blankly again, tears welling up in her brown eyes.

'Look, when is the baptism?' Hyrum said softly.

'On Saturday, a week from today, at 11:00'

'I'll be there,' he said, placing his hand on her car door.

She put the car into gear and, pausing to wipe her eyes, said, 'That's great Hyrum. You can go tell her that you're not baptizing her.'

Born Again

He looked again at the ground.

'I'll pick Clara up after school on Monday,' she said, preparing to drive off.

'I hear that Josephine's sick,' Hyrum said, 'Is it serious?'

'Yes, it's serious Hyrum,' Jesse replied, pulling away. 'She's got cancer and she's dying.'

'She's dying?' he called out. 'Then what is she still doing cutting hair?'

A Novel

That which is born of the flesh is flesh, and that which is born of the Spirit is spirit. - John 3:6

5.

Walking back to the house from the street Hyrum noticed a delicate turquoise egg lying in the yellowing grass. Looking up into the old oak tree, he saw a scrub jay perched on a branch some feet from its nest. He called for Clara.

'Hey Clara, have a look at this,' he said, pointing to the fallen egg.

She strolled out of the house, book in hand.

'Oh, wow,' she said, bending down.

'Is it dead? Where are its parents?'

'Look,' he said, pointing to the jay above them.

Born Again

The large bird perched high above its nest. It turned its head side to side and revealed its jet black and deep blue markings.

'Is it alive? What should we do?' Clara said worryingly.

'Well, it would be strange if it were,' Hyrum said, scratching his chin. 'The egg should have hatched in the spring.'

Hyrum looked at Clara and could see that she wasn't going to accept a hands off approach to situation.

'But Dad, it could be still alive,' she said. 'It doesn't appear to be broken. We've got to help it.'

'I suppose we could attempt to put it back in the nest,' Hyrum said reluctantly.

'But will she still want the egg if we touch it?' Clara replied.

'Well, that's a good point. Let's get a plastic bag from the kitchen. We'll use the bag to pick it up.'

Taking charge of the situation Clara said, 'I'll stay here with the egg, you go get the bag and a ladder.'

'Alright,' said Hyrum, 'I'll be right back.'

Having retrieved the items from the house, Hyrum paused at the front door to observe the figure of Clara hunched over the egg. Like the jay, she turned her head side to side, looking for predators. She then turned her head sideways and carefully examined the egg. The dotted dark gray markings were backlit by the turquoise and appeared to oscillate and swirl.

'Dad,' she said, noticing Hyrum at the door, 'don't you think this egg looks like it could have been painted by an artist? Look at how amazing it is.'

Hyrum approached, leaned the ladder against the tree, and crouched down beside her. 'You're right, it's beautiful.'

Side by side they observed the object. After a time Hyrum whispered, 'The markings look like the stars and galaxies.'

'Yeah, they do,' Clara whispered back. 'How does it happen?' she went on.

A Novel

'The stars and galaxies?' Hyrum said.

'No. The egg. The design. Well, and the stars even? How did it all happen?'

Hyrum thought about what to say. Being honest with her, he replied, 'I'm not really sure, Clara. I was reading the other day that we all have our origins in the explosions of stars. As planets like Earth formed they brought some of this starry matter into their orbits. The scientist said that this matter contained the building blocks of life. So, it sounds like we began as star dust.'

He asked, 'What do you think?'

'I don't know. I like the idea of being from stars. Mom says that God created everything.' She paused to think, 'I don't really know what happened. To me it seems like an awful lot for God to do.'

'I agree,' Hyrum replied.

Following Clara's copious instructions, Hyrum placed the ladder below the nest and carefully picked up the starry egg with the plastic bag. Cupping it to his chest he was struck again by just how exquisite and fragile it was. Placing the wrapped egg in his left hand and climbing the ladder, he tensed up with the thought that he was holding a precious galaxy. The adult jay flew to a branch at the top of the tree.

Reaching up to place the egg back in the nest, he looked down to see Clara steadying the ladder. This calmed him, and he looked again to the nest. With a gentle release the egg took its place next to the others.

Coming off the ladder, Hyrum took Clara by the hand. They stood and quietly observed the jay, the rustle of the drying oak leaves in the light wind, and the precious nest. After a time they walked back to the house with ladder and worn book in hand. Clara asked, 'did we save it Dad?' Hyrum replied, 'I hope so Clara.'

Born Again

Clara got up on the couch and watched the nest through the window. The jay had made its way back to the lower branches of the oak near the nest. It continued to look side to side with concern.

Hyrum sat down in the red chair and observed the scene. He decided it was time to broach the topic of the impending baptism. He had avoided discussing the issue with Clara as he wasn't sure how to approach the situation. She hadn't brought it up in conversation, so he'd let it be.

'Hey, Clara.'

'Yeah,' she replied, distracted by the happenings in the oak.

'Mom says you're getting baptized on Saturday,' he said. 'She says Uncle Bud is going to baptize you.'

'Yeah,' Clara replied, turning around.

'I'm really sorry that it's not me doing it, Clara.'

Bringing her knees to her chest and fixing her mouth, she replied, 'It's ok Dad. I figured it's not really your thing anyway.'

Hyrum ran his hand over his mouth.

'Is it really your thing, Clara?' he said, trying to compose himself.

'I'm not sure. Why *do* we need to get baptized?'

'I'm not really sure,' he said, being careful with the issue. 'I suppose people think that it will save them.'

'But why do people need to be saved?' she asked.

'Folks think that we are fallen sinners,' he replied.

'But, am I a sinner?' Clara said, looking at Hyrum sincerely.

'No, love, you are not a sinner. I think we're all learners,' Hyrum said, feeling his emotions swell again.

'Then why do we need to get baptized?' she asked again.

'I guess most people around here do it because everyone else does,' he responded.

A Novel

'Yeah, I guess I'm doing it because it will make Mom happy,' she replied.

'You know I'll be there on Saturday,' he said, reaching forward and taking her hand.

'I know you will Dad,' she replied. 'Can we talk about books now?'

Born Again

Marvel not that I said unto thee, Ye must be born again.
- John 3:7

6.

Hyrum and Clara spent the next two evenings discussing books and big ideas. They enjoyed taking turns asking one another what they called 'thinking' questions. The questions were inevitably followed by long discussions that raised more and more questions. 'Why do you think the moon doesn't fall from its orbit?' Clara puzzled. Hyrum followed up with, 'How do you think a salmon knows how to make the long journey back to its birthplace?' Clara wondered, 'How do you think Josephine wins the pie contest every year?' After speculation about whose orchard the apples came from, apple varieties, types of pie crusts, and secret spice combinations, they finally concluded that the

judges were probably just too scared to award the coveted annual prize to anyone else.

'So,' Hyrum said, tucking Clara into bed, 'what has Mom told you about Josephine?'

'That she's pretty sick,' Clara replied.

'Did she seem sick when she was cutting your hair?' he queried.

'Yeah, but she talked with Mom the whole time about working at Lee's, cutting hair, and church stuff.'

'Hmm,' Hyrum said, tilting his head in a gesture of concern. 'Things don't sound good for her. She might die.'

'But can't the doctors save her?

'I'm sure they're doing all they can.'

'Dad,' Clara said, sitting up, 'What do you think happens when we die? Do we go to heaven?'

'Oh Clara, that's a big question,' he said, positioning himself on the edge of the bed. 'I'm not really sure. Some think we go to heaven; some think that after we die we are reborn into another life; some think that we just die and that's it; others, like me, don't really know. Perhaps we somehow just join the energy of the universe.'

'Yeah, I guess I don't really know either,' she said scratching her chin. 'Dying must be scary. I guess that's why heaven sounds pretty good.'

'I think you're probably on to something there Clara. But perhaps dying shouldn't be that scary. We all do it, and maybe it's not as bad as we think. For people that suffer it might even be nice.'

'Maybe being dead is like being unborn, it's not really good or bad,' Clara said with remarkable clarity, 'it's just sad for the people who are left behind.'

Born Again

Hyrum nodded and leaned back against the footboard of the bed, letting Clara's truth resonate in his chest.

'Guess what I have?' she said, changing the subject. 'Remember that book you gave me?'

'Which one?'

'This one,' she said, reaching over the bed to her backpack on the floor. She pulled out Bombrich's *A Little History of the World*, showed it to Hyrum, and began thumbing through the first chapter.

'You know my Dad gave that book to me over twenty years ago? It was one of my childhood favorites. I'm glad you're getting around to reading it,' Hyrum said.

'Yeah, Mom took most of my other books away,' she said flatly. 'This one was hidden on my bookshelf.'

Finding her place in the book and then looking back up at Hyrum she said, 'Maybe dying is kind of like something he says about lighting a piece of paper on fire and dropping it down a well. The light of the fire is kind of like being alive. The paper falls slowly,' she said, now reading from the text, 'and as it burns it will light up the sides of the well. It is going down and down. Now it's so far down it's like a tiny star . . . It's getting smaller and smaller . . . and now it's gone.'

Hyrum stared at Clara.

'So maybe we really are like the stars,' she said. 'We burn bright at first and then less and less until we burn out.'

'It couldn't be better said,' Hyrum replied, feeling a glimpse of truth.

'But maybe we never do go away entirely,' he said. 'As I recall, earlier in the book he uses the analogy of mirrors.'

'Oh yeah,' Clara replied enthusiastically.

'Wait just a minute,' Hyrum said getting up and leaving the room. He returned with the bathroom mirror and propped it

A Novel

carefully against the bedroom wall, across the room from the mirror on the closet door. 'Now come over here and stand by me,' he said, positioning himself between the two mirrors.

Clara got out of bed and stood next to Hyrum. Standing together Hyrum realized just how much she had grown in the last year. With her head now reaching his mid torso he felt the acute ache of fleeting time and a father's desire to claw it to a halt.

'You know, your Grandma Clara would be so proud of you,' he said.

'Yeah,' Clara replied, seeing the two of them stretched into infinity in the long line of mirrors.

'Now turn around,' he said.

They both turned and saw the same eternal pattern repeated.

'Maybe this is how it really is,' he said. 'We stand here in the present, but we stretch out forever in front of us and behind us – in the future and the past.'

'This makes me feel better, Dad,' Clara said softly, wrapping her arms around his waist.

'Me too, love,' he replied, 'me too.'

Born Again

That whosoever believeth in him should not perish, but have eternal life. – John 3:15

7.

'Clara,' Hyrum said in an excited whisper, 'Hey, I've got something to tell you.'

Waking up, Clara rubbed her eyes and replied 'Yeah? What is it?' she asked.

'Can you keep a secret?'

'Sure,' she said, finding her bearings.

'I think I found the buck.'

Clara sat up and faced him. 'You what?' she puzzled.

'*The* buck,' Hyrum said, leaning forward from the foot of the bed and widening his eyes.

'You found it? But where?' she asked.

A Novel

'Up on Juniper Mountain. Do you care to see a picture of it?'

He motioned her to the kitchen where the deer camera lay on the table. Clara grabbed her hairbrush from the bedside and followed him to the kitchen. Flipping through the images, Hyrum came to the foggy image of the trophy animal.

Taking the figure in Clara gasped, 'Wow, that's big! It must have twenty points on its antlers!' She marveled at the image a bit more and asked, 'But Dad, why is the picture so blurry?'

Hyrum went back through the images and showed Clara the nosy doe. He acted out the meddling creature's doings with the camera much to her enjoyment.

'So, how did you find it?' she queried, combing her hair and taking a seat at the small dining table.

'Well, I found a nice little canyon on the east side of the mountain about six months back. I thought it'd be a spot where deer might occasionally bed down. It seems to be a place that few people know about.'

'Do you think you'll get it then? The buck?' Clara inquired.

'Oh, we'll see. I'm going to try,' he said, getting some breakfast together. 'You've got to promise not to tell anyone about it. Otherwise, the whole town will follow my every move. You know Levi Heber couldn't keep his mouth shut about the whereabouts of his sighting. Apparently he swore two of the Hafen boys to secrecy about the spot. When he went back to scout the buck last weekend he was greeted by a dozen other hunters.'

'I promise I won't tell,' she replied.

'You're the only person I've told, and I plan to keep it that way,' he said, pouring himself a cup of coffee.

'I like that smell,' she said, referring to the coffee.

'It's nice isn't it,' Hyrum replied.

Born Again

'Mom said that Uncle Bud had to stop drinking it for at least a month to baptize me.'

'The poor guy,' Hyrum said shaking his head, 'he had to do the same when he baptized me.'

'But why is coffee so bad?' she asked.

'I'm not sure Clara. I don't know that it is really all that bad. I suppose folks think that it can be addictive.'

'Are you addicted?' she asked worried.

'I'm not really sure. I only have a cup of it a day. I like the taste and it helps wake me up in the morning.'

'That doesn't sound so bad,' she said taking a drink of milk.

'Yeah, I think we sometimes make such a big a deal of these small things that we forget the important things,' Hyrum replied. 'You ever think about how strange it is that we all drink milk from another species every day? Why don't we talk about that?!'

'Hey,' she said wiping her mouth with her forearm.

'So, Mom's picking you up after school today. We've got to make sure you're packed and ready to go.'

'Ok,' she said, spreading some of Aunt Laverne's apple jam on her bread.

'Look, I won't see you until the baptism on Saturday,' Hyrum said, taking a seat across the table.

Clara nodded her head in acknowledgement.

'Do you feel ready for it?' he asked.

'I guess so. Uncle Bud and I practiced it last Sunday at church. He was pretty nervous and kept mixing up the words.'

'I'm sure everything will be fine. You know, it was Uncle Bud that baptized me at the church when I was eight. He mixed up the words then too,' Hyrum laughed, remembering the event.

'Why didn't your dad baptize you?' she inquired.

'Well,' Hyrum said, pondering the question, 'I guess it just wasn't his thing.'

A Novel

'Well,' Clara replied, 'will you stand at the front of the baptism font so that I can see you?' she asked.

'Hmm,' Hyrum cleared his throat, 'you know, putting myself front and center would a little awkward considering that folks think I'm the one that should be baptizing you. Would it be ok if I stood off to the side a bit?'

'Yeah, I guess that would be ok,' she said. 'Just don't stand in the very back.'

'It's funny that you say that. That's just what my dad did when Uncle Bud baptized me.'

Born Again

How can these things be?
- John 3:9

8.

The early approach of winter had spurred the good people of Butte to survey their annual need for firewood and coal. For his part, Hyrum figured he needed somewhere around four cords of wood to conservatively heat his small house for the season. As he didn't like the smell of coal and liked the particular heat and crackle of hardwood, he placed his wood order with Merle and Cimarron LeByron early. Like most folk in the area, Hyrum didn't like running the furnace because of the exorbitant gas bills and the way the forced air seemed to further dilute the already dry, high desert air. Above all, running the furnace imparted a feeling of dependency on the outside world that sat poorly in the stomach.

A Novel

Autumn was the busiest and least favorite season of the year for the LeByrons. While it was a time when they earned the bulk of their annual income, they detested leaving the comfort of their solitary canyon cabin and spending so much time in town. In Butte they felt they were constantly watched and judged. It would have hurt them to know that most parents used the LeByron name when teaching their children about the perils of iniquitous living. It's not that the LeByrons weren't believers in the gospel; quite to the contrary, it's just that they didn't conform to the clean-cut social mold of Utah Mormonism. Their ragged stringy hair, abundance of facial hair, and old wrinkly flannel cowboy shirts gave them a rustic unkempt look that had a certain unsettling effect on the town folk.

Hyrum scheduled the LeByron wood delivery for Tuesday evening. While he would have liked to have Clara formally meet the brothers, he knew Jesse would give him untold grief if she got word of Clara mingling in any way with the town inebriates. Always punctual with their deliveries, Hyrum heard the rattle of the overburdened old trailer and particular squeak of Merle's overused brakes when the rig was three blocks away. As the LeByron's pulled up to the house with four cords of their finest, Hyrum walked outside and took note of the sweet and sharp mechanical smell of the outfit. Merle's '82 Ford F100 looked worse for the wear.

'Damn truck's 'bout to give out on me,' Merle said, getting out of the vehicle. He walked toward the house and reached out for Hyrum's hand.

'I remember your uncle Frank driving that truck when I was kid,' Hyrum replied. 'You've done a nice job keeping it going.'

Cimarron was slow getting out of the passenger side of the truck cabin. From the corner of his eye Hyrum observed the

Born Again

broken man carefully maneuvering himself and favoring his left leg.

'Cimarron's always tellin' me that that truck is my mistress. He calls her Lucile. I reckon he's right,' Merle said, shaking his head. 'She demands all my attention. Trouble is, just when I repair somethin' on 'er, anothern goes,' he paused. Come to think of it, he's got it all wrong. She's not my mistress, she's my old haggard wife!' he quipped.

Merle looked over his shoulder to see his brother hobbling toward them.

He leaned close to Hyrum and said in a hushed voice, 'you seen them prices on the new Fords down at Herb's lot? That man must be out of his head. What I want to know,' he asked sincerely, 'is who's got that kinda money?'

Weighing the appropriateness of what came to his mind and taking a risk, Hyrum replied, 'I don't know, perhaps Elder Smith?'

Merle responded with a quizzical brow that transformed into a genuine smile. He slapped Hyrum on the back and said, 'Amen brother, Amen.' The two men savored a quiet moment of mutual understanding.

'Well ain't that the truth my good sir, ain't that the truth,' Merle responded, looking Hyrum in the eye.

'Hello Cimarron,' Hyrum said, holding out his hand.

Hyrum picked up on the pungent smell of alcohol wafting off of the younger LeByron.

'Did I hear one of you mention that bastard Smith?' Cimarron said, taking Hyrum's hand with a firm grip. 'That no good philanderin' sum bitch,' he continued, looking first at Hyrum and then at his brother. 'What I wanna know is just how that half-man, half-ass Smith done what he done to me and then gone and got himself promoted into the bishopric of the church? I mean Goddamn, ain't that some biblical hypocrisy?'

A Novel

'Sure is brother,' Merle said with sympathetic patience.

'Now I gather he's out consortin' with your wife,' Cimarron carried on, looking at Hyrum.

Hyrum fixed his mouth and nodded his head. 'Yep, apparently they're engaged to marry,' he replied. 'Though I suppose Jesse and I have now been divorced for some six months,' Hyrum said in a tone of fairness.

'That done matter nothin,' Cimarron shot back. 'He's a scoundrelizin', womanizin' thief.'

'Alright, alright,' Merle said reaching his arm toward his brother, trying to make him aware of the sensitive issue.

'Nobody but me daren' say it,' Cimarron carried on, ignoring Merle. 'You know, I don't trust the whole lot, them turkey-ass leaders of the church.'

'Yeah,' Hyrum nodded again, 'I've had my run ins with them too.'

'That pig shit of a Bishop had the gumption to excommunicate me a year back just because I was runnin' around with the Maynard girl,' Cimarron said incredulously.

'Agnes Maynard is his niece Cimarron,' Merle said with a laugh. 'You sure know how to pick em.'

'Oh the hell with that,' Cimarron replied. 'Old Hafen had wanted to cull me from his flock for ages. He just needed an excuse.'

'You don't think that it'd nothin' to do with the fact that you were consortin' with that false prophet over in Coalville,' Merle said, goading his brother.

'Well shit, why you goin' and bringin' that up Merle?' Cimarron said lighting a cigarette. Hyrum noticed how the yellow pearl buttons on Cimarron's shirt were a fine match in both the shine and color to the younger LeByron's teeth.

Born Again

'Never mind old prophet Zachariah,' Merle said with a smile. 'Let's unload the wood.'

As Hyrum and Merle took wheel barrel load after load of wood and dropped it on the side of the house, Cimarron leaned against the old oak tree and angrily chain-smoked his cigarettes. He muttered occasional curses at the Church leadership and raised his arms to gesticulate his fury. The scrub jay followed the goings on and scrutinized the younger LeByron, hopping from branch to branch.

Twenty minutes later, with the truck and trailer unloaded, Hyrum decided he'd take another risk and offer the LeByrons a drink.

'Can I get you gents a beer?' he asked.

The brothers looked at one another puzzled. The thought entered their heads that Hyrum was joking.

'You serious?' Merle asked.

'I know it seems odd, but you're not the only ones around here that enjoy a drink,' Hyrum replied.

'But we thought that you . . .' Cimarron started.

'Don't worry about that,' Hyrum said. 'Give me just a minute.'

As Hyrum walked to his truck on the other side of the house he took notice of the orange and pink sunset over the western cliffs of Butte. While he praised sunsets for their exquisite beauty, he admired them more because they brought focus to the expansive and oft times overwhelming desert sky. Reaching his truck, he fished around inside the bag from his Sunday purchase at Lee's Junction. He felt around the unopened bags of jerky and sunflower seeds, the half empty bottle of whiskey, and finally came upon the remaining three cans of beer.

Returning to the woodpile, Hyrum saw the brothers fast at work stacking the wood in neat rows.

A Novel

'Hey, don't bother yourselves with that. That's my job,' he said trying to get them to stop.

'Hell, it'll only take a minute,' Cimarron said bracing himself on the side of the house in between tossing Merle pieces of wood to stack.

Hyrum had always taken pleasure in the solitary and contemplative act of stacking wood, but somehow stacking with the LeByrons seemed infinitely more enjoyable. As they worked, Cimarron carried on blasting the church leadership and filling the two men in on the details of his excommunication.

'I'm a truth seeker,' he proclaimed. 'That's why, brother Merle, I got into that trouble with that prophet. You think I can follow ole Bishop Hafen and his crony councilors Smithy and Jessop? They're out there chasing the great whore of Babylon worse than the rest of us. No damn way brother.'

'You know,' Cimarron continued, 'if that false prophet Zachariah wasn't so bent on polygamy we could've had something going.'

'I've heard about the polygamists in Coalville' Hyrum said. 'Are you referring to Zachariah Platt, the mechanic?

'That's the man,' Merle replied, rolling his eyes.

'He's a fiery man of the book,' Cimarron said. 'He didn't mind that I drank, cursed, or smoked. As long as I believed in God, Jesus, and, of course, him as Prophet, everything else was ok. That's how he hooked me. The trouble began when he proposed I marry his sister Delores. When I went 'round his place to meet her, there was not one but two women sittin' there on that sofa. Zachariah said that in order for me to fulfill my spiritual obligations I needed to marry them both. He said it was God's command. I was troubled. Neither Delores nor her sister Irene was any easy on the eye, but I told him I'd think about it. In the end I couldn't go

Born Again

through with it. I've never lived with one woman before; I just couldn't imagine tryin' to live with two.'

'I think he was just trying to off load those sisters on to you Cimarron,' Merle said, placing another piece of wood on the stack. 'He's been looking after them spinsters for years.'

'I reckon you're right,' Cimarron replied. 'You know, it takes religion to make good people do bad things.'

Hyrum was so astonished by the statement he nearly lost his footing. He raised his head to the sky and laughed aloud. Composing himself, he handed out the beers. 'I can't thank you gentlemen enough,' he said raising his beer to Merle and Cimarron.

'Aw, it's nothing brother Hyrum,' Merle replied.

Raising his can Cimarron added, 'Many thanks for the beverage and fine conversation, brother.'

Hyrum had been called 'brother' his whole life by members of the Church. Until now he never felt he was anyone's true brother. He smiled and swigged his beer.

A Novel

We know that thou art a teacher come from God: for no man can do these miracles that thou doest, except God be with him.
- John 3:2

9.

For Hyrum James, teaching at the secondary school in Butte was akin to walking a tight rope. He had learned to strike a fine balance that wouldn't overly upset the community's applecart on one hand, and that would promote his educational ideals on the other. As he came to find out, this approach wasn't so easy; the one hand at least outwardly seemed to condemn the other. It was natural that Hyrum occasionally landed himself in Principal Willard's office for what Willard deemed 'too much intellectual enthusiasm'.

Fortunately for Hyrum, old age had pushed William Willard into becoming a benevolent and patient man. While the community perceived his shift in attitude as a genuine change of

Born Again

heart about how to run a school, Willard knew his transformation from a high strung micromanager to a mild-mannered school patriarch was driven largely by the fact that unpleasant things gave him very uncomfortable moments of heavy indigestion and aggravation of the bowels. Willard had all but lost his zealous managerial approach and preferred instead to skirt around contentious issues or stay close to the toilet.

Moments before the Thursday afternoon staff meeting Willard felt obligated to call Hyrum into his office. Sitting behind his desk and tenderly rubbing his troubled lower belly, Willard motioned for Hyrum to take the seat opposite. Hyrum, with his mind set toward the following day's parent conferences, readied himself for the standard preface.

'Now Hyrum,' Willard said, chewing a pink antacid, 'you're young and energetic. You're also a valuable member of this staff.'

'Thanks Bill,' Hyrum said, 'but I'd like to...'

Willard raised his hand and cut Hyrum off. 'The trouble is that some of our parents don't appreciate you making certain comments in class.'

'What exactly are we talking about Bill?' Hyrum queried, 'What comments?'

'Oh, I don't know,' he said, reaching for another pink tablet and releasing a small burp. 'Pardon me. The comments?' he said in a feeble attempt to delay. 'Oh, I suppose it was something you said about those Eastern Buddhas, some Chinese God, or something or other over there,' he let out, pointing with his free arm in the direction, Hyrum presumed, toward Asia.

'Ok?' Hyrum said nodding and trying to pinpoint in his mind the particular lesson.

Willard was now clearly uncomfortable in his Principal's chair. He shifted back and forth.

'Just who are we talking about Bill?' Hyrum asked.

A Novel

'That's of no real consequence Hyrum. The point is that some of our parents . . .'

Willard stopped mid sentence, looking somewhat alarmed. He stood up carefully. 'Just give me a minute young man.' He hobbled cautiously out of his office to the bathroom across the hall to relieve himself.

Hyrum was glad for the interruption. It gave him time to reflect. After a brief moment he had it. A week earlier he had led a grade 9 class discussion about transcendentalism following reading an excerpt of Emerson's *Nature*. For contextual grounding, Hyrum had related how the 19th century transcendentalists were influenced by Eastern philosophical traditions of Buddhism, Confucianism, Hinduism, and Taoism. He conveyed how the transcendentalists believed that the organized religion and politics of the 19th century tended to corrupt the purity, intuition, independent thinking of the individual.

Hyrum remembered the classroom conversation. 'Wait,' Eustace Jessop spoke up, 'are Buddhists those weird guys that sit around all day in yellow robes?'

"Weird' is an interesting concept,' Hyrum replied. 'What makes you say Buddhist monks are weird?'

'Well, for one, they wear those robes. They also shave their heads and sit around chanting all day,' she said as a few students laughed.

'That does seem different to what you or I might do,' Hyrum said. 'But does that make their actions 'weird'?'

'Consider this,' he continued, 'what if you brought that yellow-robed chanting monk home to Butte, Utah to live with your family for a week.'

Eustace blushed to more student laughter.

'Say you took him to the rodeo, to your church meetings, here to school, or out to get a burger and fries with your friends. What

Born Again

if you dressed that monk up in Wranglers, boots, t-shirt, and a cowboy hat and plopped him behind the wheel of your Dad's Chevy Silverado with country music on the radio? Don't you think the monk might see some of this as weird?'

'I suppose so,' Eustace said.

'So, if these things would be as foreign to him as his customs are 'weird' to you, doesn't that also make you 'weird'?'

'But come on Mr. James, you have to admit that they are weirder than us,' Clancy Stout chimed in. 'I mean, what are they meditating about all the time?'

'So, are you saying there are different levels of weirdness?' Hyrum replied.

'Yeah,' Clancy said bluntly.

'But who decides what weirdness is? And what about the criteria for weirdness? Who decides the weirdness criteria? Is it you,' Hyrum said, motioning to the whole class, 'or the monk?'

'Eustace and her monk can figure it out together,' Sam Hamblin said, to the joy of the students.

'Alright, enough of that,' said Hyrum.

'And finally,' Hyrum continued, 'who gets the final say about who gets categorized where?'

'I do,' Clancy said.

'Heaven help us,' Hyrum replied, laughing with the students.

'Eustace's point,' he said, drawing the students back in, 'her point revealed to us an interesting problem about the nature of perspective and judgment, and that is . . .'

'But wait,' Clancy called out, 'you never answered about what them monks meditate about.'

Hyrum thought that Clancy wouldn't let it go.

'Let us first finish with the thought,' Hyrum replied. 'What have we learned?' he said, looking at Clancy

A Novel

'I suppose it's not that the monk is so weird,' Clancy said, 'it's just that he does things differently.'

'Good,' Hyrum said satisfied. 'I think you've largely answered your question.'

'How so?' the student asked.

'Well, many of us in this room pray,' he replied. 'You might think of Buddhist meditation as a quiet time of reflection, somewhat similar to prayer.'

'So are they praying when they're sitting there?' asked Sam.

'In a sense, although they might not be giving thanks and asking for things in the same way many of us do. Look, I'm no specialist in Buddhism,' Hyrum said cautiously, 'but I've read that monks focus on breathing and attempt to rid their minds of distractions during meditation. I suppose in the end the monk is seeking spiritual communion and wholeness just as many people in the community here in Butte do. His approach is just different. In that sense, he is not so different from folks around here.'

'So, we can begin to see just how our monk is tied to the transcendentalists,' Hyrum said in an attempt to bring the discussion back around to the lesson.

'What does it mean to 'transcend'?' Sam asked.

'Class?' Hyrum said, hoping to elucidate an answer from the students.

'It's when you rise above things,' Eustace replied.

'Exactly,' replied Hyrum. 'See, people like Emerson, Fuller, and Whitman were saying that we need to rise above those things around us that mold our thinking and push us to conform. This is how we rediscover our true selves.'

'Sorry about that,' Willard said, entering the office and jarring Hyrum back to the present. 'What I was saying is that some of our parents don't appreciate you bringing that stuff up. Their kids

Born Again

come home with, well, with questions,' he said, sitting back down behind his desk.

'I need you to just stick to the lessons. Just tone it down a bit. I'm sure you don't want Brother Jessop calling me as much as I don't.'

'So, it was Eustace that told her parents about the lesson with her,' Hyrum thought.

'I really struggle with all of this Bill,' replied Hyrum.

'What do you mean?' Willard questioned.

'Well, there are times in the lesson when the students reveal some lazy assumptions about things or raise good questions. What am I to do in those moments? Deny them the opportunity to explore their thinking, their culture? This is the heart of learning. You know, I once heard it said that the problem with the world is that ignorant people are full of confidence while thinking people are full of doubt. I'm trying to change that.'

'You can't take it too far, Hyrum,' interjected Willard, rubbing his chest. 'Look, Brother Jessop doesn't want his kid exposed to any discussion about religion that doesn't focus on our Lord and Savior Jesus Christ.'

'But he missed the point. I wasn't advocating this or that about religion, I was just trying to get the students to reflect a bit about their cultural assumptions,' Hyrum said, feeling frustrated. 'School should be about teaching one how to think, not what to think.'

'Be that as it may, Hyrum,' Willard said, 'the parents in our community make up our school board. They vote on the school budget and they can put pressure on me to let people go.'

Hyrum opened his mouth to speak but paused. He felt defeated. He had had this conversation before.

A Novel

'You are a young, energetic, and valuable member of this staff,' Willard reiterated, 'and I don't want to lose you.' His mind was already moving on toward the evening's parent conferences.

'Thanks Bill,' Hyrum repeated, reflecting on Eustace's comment about what it means to transcend, 'I appreciate that.'

Born Again

Art thou a master of Israel, and knowest not these things?
— John 3:10

10.

With his divorce and hiatus from church, Hyrum found parent evenings at the school put him ill at ease. It wasn't the students that brought on the anxiety – the teens of Butte certainly thought of Hyrum as unconventional, but they trusted and respected him because of his authentic approach – rather, it was the judgment of the parents that left Hyrum feeling a steady sting of disapproval. Most of the meetings began with small talk that sputtered out quickly to be followed by awkward pauses and the inevitable discussion about assignments and grades.

'What are you teaching these kids Hyrum?' questioned Earl Jessop as he and his plain and quiet wife Martha pulled up chairs opposite Hyrum in his small corner classroom. Hyrum lowered his hand that Jessop had refused to shake.

Familiar with the routine of deferring to her husband, sister Jessop sat quietly and looked into her lap. Her heart raced with

A Novel

embarrassment. Seeking distraction, she studied the contours of her worn hands and looked in vain for their youthful luster. She wished Earl wouldn't be so combative.

The couple looked like overstuffed siblings. Brother Jessop was a large and imposing man that smelt strongly of aftershave and malodorous meat. His fragrant presence always came as bit of an olfactory shock to even his closest acquaintances. Hyrum wondered for a moment what could be happening with the man. It dawned on him for the first time that the copious daily application of aftershave was indeed a feeble attempt on Jessop's part to cover up his unfortunate natural musky smell. Hyrum felt pity for the man and realized that he was probably the last person in Butte to make the amusing connection.

'I suppose I'm teaching my students to think,' replied Hyrum, regretting the words as he uttered them.

'I thought this was an English class,' Jessop puzzled sarcastically, feeling around his pockets for his daughter's schedule.

'Yes, of course . . .' Hyrum replied.

Jessop held up his free hand to silence the teacher. Finding the folded paper in his shirt pocket, he opened it up and slowly flattened out its wrinkles on the desk separating the couple from Hyrum.

'Yes, it says here 'English 9 - Mr. James, room 104'. Now, unless I'm mistaken, I saw that this is room 104 as I stood just outside the door.'

Martha clenched her jaw. Her hands were clammy and her stomach turned. She looked out into the dark through the small window to her right as if she could see something important there. Hyrum followed her eyes and sensed that this searching was something that she often resorted to.

Born Again

'I'm sorry Mr. Jessop. What I meant to say is that through our English studies I encourage the students to think about their thinking and to develop their skills in rhetoric, persuasive writing, and critical analysis of literary texts and ideas.'

'That doesn't sound like English to me,' huffed Jessop. 'Look, as I see it you're taking liberties and straying from the curriculum. I mean, what on Earth does talking about that Buddhist nonsense have to do with English?'

Hyrum leaned forward, placed his elbows on the desk, and brought his hands to his forehead and then slowly to his chin.

'The students asked about it, and I saw it as a teachable moment,' he replied, feeling trapped.

'You see, that's the problem right there,' responded Jessop, leaning in. 'Just because some kid gets a wild hair to ask some odd thing, it doesn't mean you need to indulge 'em and go on and on about it. And just what are these young kids going to do with that kind of fluff floating around in their heads? It does them no good and it's certainly not faith promoting.'

Jessop leaned back. Hyrum swallowed hard, realizing that Jessop was not interested in a response.

'Stick to the books Hyrum or else I'm gonna raise a real stink.'

Seeing the humor in the statement, Hyrum covered his mouth to hide his amusement.

It then dawned on him just how suffocating it must be for Martha to married to such a man. For a flash of an instant he felt the empathy of oppression. He struggled to breathe.

Composing himself, Hyrum noticed sister Jessop's neck and face were flushed. He knew she desperately wanted to leave. He made a fumbled apology but stopped short of saying that he would change his approach to teaching. Suspecting that Jessop wasn't interested in discussing Eustace's progress in the class, he

A Novel

asked if there was anything else the couple would like to talk about. Martha was again looking at her hands.

'No, that's it,' Jessop replied, standing up and zipping up his jacket.

As Martha followed suite, she met eyes with Hyrum. He detected an expression of apology mixed with sadness and resignation.

'Ok, goodbye,' Hyrum said, standing up and giving Martha a subtle sympathetic look.

After the Jessop's departure, Emma peaked her head inside the door.

'Are you free?' she said with a welcome smile.

'Hey, you bet, come on in,' Hyrum replied, grateful for the distraction.

'I'm sorry, but I don't have an appointment.'

'Please, don't worry about it,' Hyrum said, shaking her hand. 'With the way things are going tonight I think there will be plenty of free time in my schedule.'

'Yeah, what did you do to the poor Jessops?' she joked with a whisper. 'They didn't look too happy leaving here.'

'What did I not do?' Hyrum replied, shaking his head and gesturing Emma to have a seat.

'Don't take it so hard Hyrum,' Emma said sitting down. 'That Jessop fellow is a real piece of work. In Navajo we'd call him 'Yáadilá t'a'iiyahii.''

'What does that mean?'

'A butthead.'

'That's fantastic. How do you say that again?'

'Yáadilá t'a'iiyahii.'

'Yáa dilá t'a 'iiya hii,' he repeated slowly in fragmented Navajo.

Born Again

'I hope my dad isn't boring you to death with his lectures at the community college.'

'No, not at all. He's a very knowledgeable and passionate lecturer.'

'Yes, so passionate that at times he forgets he's got students sitting in front of him!'

'No, I'm really learning a lot from him. He's a very good teacher.'

'So how's Sam doing?' she asked, enquiring after her son.

'His academic work is truly outstanding. His recent essay on Shakespeare's use of imagery and foreshadowing to illustrate the follies of power and pride in *Macbeth* was one of the best I've read as a teacher. I can tell he's an avid reader and a thinker.'

'That's really good to hear. I don't get much out of him these days. He seems to be in the one-word phase when it comes to conversations,' she said, gearing up to mimic her mother and son interaction.

'How was school?'

'Ok'

'How did that science assignment go?'

'Fine'

'What'd you do after school?'

'Basketball.'

'You making friends?'

'Sure.'

'So what are you reading?'

'*Dune*.'

'You like it?'

'Sure.'

'I can't keep his nose out of books,' Emma said exasperated.

'It's funny; my daughter Clara is just the same. It drives her mother crazy.'

A Novel

'I suppose it's better than other things they could be doing,' Emma said nodding her head.

'Exactly,' Hyrum replied.

'And what about his participation in class?'

'Well, he doesn't say much. He's quite reluctant even when called upon. It's a goal of mine to get him as comfortable with his speaking in class as he is with his writing. It'll take some time, but I think we'll get there.'

'Anything you can do in that way would be much appreciated. His father was pretty hard on him you know,' she said shaking her head. 'I think Sam has some real insecurities and issues with trust. As if being a Navajo teen isn't hard enough.'

Hyrum nodded sympathetically. 'Well, kids are pretty resilient. While each of us carries our baggage into adulthood, we generally seem to make it through. I'll continue to keep a special eye on him.'

'It means a lot Hyrum,' Emma said feeling a surge of emotion.

She stood up, held out her hand, thanked Hyrum again, and departed before he could see her cry.

The rest of the evening went off without much ado. As usual, the parent visits to the school felt more like an obligatory social event than an authentic opportunity to discuss education and learning.

Principal Willard walked down the halls turning off lights, thanking his teachers, and wishing everyone good evening.

Hyrum readied his room for tomorrow's lessons. As he did, he noticed a small black spiral bound notebook lying on the floor next to the desk where he and the parents had had their conferences. He opened it thinking it belonged to one of his students. The pages were full of musings, daydreams, illustrations, and notes. He recognized one of his dad's lectures on the sublime amongst the notes. The notebook was Emma's.

Born Again

He that was with thee beyond Jordan, to whom thou barest witness, behold, the same baptizeth, and all men come to him.
— John 3:26

11.

Hyrum awoke on Saturday morning with knots in his stomach. He hadn't slept well. When sleep did finally overtake him in the early morning he dreamt of being adrift on a raft, rudderless, in dark and turbulent waters. When he yelled for help, his voice was drowned by the wind. When he shouted louder, the wind grew stronger. Great and terrible waves overtook him, capsizing and sweeping away his vessel. He fought to stay at the surface, kicked off his boots and freed himself of his heavy jacket. Just when he was sure of his end, the storm calmed and the water stilled. He looked around in vain for a sign, something. There was nothing. He floated on his back, gazed above, and beheld the cold and gentle

A Novel

canopy of stars. He felt awe and wonder at the grandeur of the firmament. He then turned over, held his breath, and peered below into the great watery abyss. The void beckoned, awaiting the arrival of the voyager. He thought, 'what an irony. I will drown while floating in space.' He treaded water for a time but eventually succumbed and slipped downward, at first fighting and then relenting. His body tingled and he felt a flash of complete and unfettered bliss before suddenly waking. As consciousness dawned he remembered, 'Clara will be baptized this morning.'

Peter had rung Hyrum earlier in the week and proposed that father and son attend the baptism together. Hyrum was glad for the offer. Despite his skepticism about the ordinance, he still felt a great deal of shame and didn't want to face the community alone as an unworthy man. In Mormon country fathers are supposed to baptize their children.

Hyrum tried to busy himself by planning for the school week ahead and flipping through back issues of hunting magazines. He found himself staring at his mother's woodblock print of desert flowers on the wall, lost in thought. The flowers were powerful yet fragile, beautiful but sad, vivid and fleeting. He thought about his mother, the duality of life, and wondered about his place within. He felt estranged from and abandoned by Butte. It occurred to him that it might be best if he moved north for a new life in the city. The idea frustrated and aggravated him. Butte was his beloved home as much as anyone else's. It was the place of his birth, his mother's death, and home to his father and daughter. 'Why does it have to be all or nothing here?' he thought to himself. 'Where's the middle, the gray space, the accommodating ground? Where's the possibility for being human?'

A knock came to the front door. Hyrum was grateful for the interruption. He looked at the clock on the wall. It was 10:32am. Peter opened the door and came in the house.

Born Again

'Morning Son.'

'Hi Dad.'

'There's a real chill in the air this morning,' Peter said, hanging his jacket. 'I hear we might get an early snow today.'

'Yeah?' said Hyrum, still caught up in thought.

'So how'd you sleep last night?'

'Poorly,' replied Hyrum, shaking his head.

'I recall not sleeping at all the night before your baptism,' Peter commented, making his way to Grandpa's red chair opposite Hyrum. 'It's hard not doing one's religious duties 'round here.'

'Tell me about it.'

'Well, if it's any consolation, at least many of the men will be out on the hunt,' Peter said.

Hyrum replied with a quiet nod.

'I spoke with Bud last night on the phone. He's nervous too. He said he doesn't like folks looking on at him.'

'I guess that's why he jumbled the words and stuttered so badly when he baptized me those years ago,' Hyrum reflected, cracking a smile.

'It should be interesting to hear what he comes up with today,' replied Peter.

'Hey, you got any more of that coffee?' Peter said, looking at Hyrum's mug on the coffee table. 'It would be nice to have a cup before we head out.'

'You bet,' Hyrum replied, fetching the coffee pot from the kitchen.

Hyrum topped up his mug and filled his dad a cup.

'I'm going to go get dressed up I guess,' he said, handing his dad the coffee. 'Give me just a few minutes.'

'No worries Hyrum, take your time. We don't want to get there early.'

A Novel

Father and son arrived at the church at three minutes to eleven. Hyrum had hoped to see fewer vehicles in the nearly full parking lot. Jesse and her folks had the spots next to Bishop Hafen's truck in front of the church entrance. They eventually found a spot in the far corner of the lot. Shutting off his Chevy, Hyrum paused before getting out.

'This situation is the damnedest thing,' Hyrum said shaking his head.

'Hey, don't take it so hard,' Peter replied, placing a hand on Hyrum's shoulder. 'You're not the first father that didn't baptize his kid, nor will you be the last. You've got nothing to be ashamed of.'

'I don't want to be accepted here for fitting into the mold. You know? I want to be accepted here for who I am.'

'That's just how your mother felt,' Peter said. 'Living in Butte and being a non-believer is a difficult thing. Few are able to do it. I know you've come to realize that it's a pretty lonesome existence.

'Indeed it is,' Hyrum replied, opening his door.

'Enough of that for now,' Peter said getting out of the truck and zipping up his jacket.

'You know,' he carried on, walking toward the church, 'these damned church gatherings always feel like funerals. It doesn't matter if it's a wedding, some blessing, a baptism, or a confirmation. They all have that same somber air about them.'

'They sure do,' Hyrum said, taking note of Merle LeByron's ragged truck parked awkwardly between Elder Smith's new pearl white SUV and Josephine's impeccably clean Buick LeSabre. The truck looked like it might be broken down.

'Well, on the bright side nobody's dead in there,' Peter offered.

'Yeah, that is good,' Hyrum flashing a slight grin at his dad.

'The whole thing will be over before you know it Son.'

Born Again

'Sounds like some medical procedure,' replied Hyrum, opening the church door for his father.

'Exactly.'

Standing in the foyer to greet the attendees were Bishop Hafen and his councilors Smith and Jessop. Peter went ahead first, shaking hands and making small talk. As he did, Hyrum noticed the Bishop's profusion of sweat on his brow. He grasped the Bishop's hot and fleshy hand.

'Welcome Hyrum,' he said plainly.

Elder Smith looked uneasy and uttered an unintelligible greeting. Hyrum returned the awkward gesture.

'We best get started,' said the Bishop, herding father and son down the corridor to the baptismal font. Hyrum was grateful for the Bishop's skillful maneuvering so that he didn't have to face and uncomfortably shake hands with Smith and Jessop.

Hymns played by a Relief Society sister at the piano set a reverent tone in the baptismal room. The enclosed area around the hot tub-sized baptismal font was quiet, dim, and filled with onlookers. Except for the young children who had settled themselves at the front of the font and peered curiously into the water pointing at their reflections, all eyes focused on Hyrum. Peter forged ahead along the near wall to the back corner of the room. Hyrum followed with his head down. He felt a gentle tug on his arm and looked up. Cimmeron LeByron offered a nod and a warm smile. His brother Merle stood at his side.

'Welcome brother,' Merle said in a hushed tone, extending his hand.

'Aren't you two supposed to be out on the hunt?' Hyrum said sympathetically and gratefully.

'Aw hell, we wouldn't miss this for the world,' Cimmeron proclaimed.

A Novel

A few people close by gasped at LeByron's irreverent statement and turned away shaking their heads.

'Do you mind if my dad and I stand here with the two of you?' Hyrum said quietly to the brothers.

'We'd be honored,' replied Merle.

'Dad,' Hyrum said, beckoning his father from the back corner of the room. Peter joined the men along the wall just as the Bishop began to speak.

Hyrum was glad to have the room's collective attention refocused on the bishop and his brief talk about the necessity of baptism. With his head down Hyrum made quick glances around the room. He saw Jesse standing to the right of the font with her fiancé Elder Smith and her parents. Sitting next to Jesse's father Herb and giving her full attention to the bishop was Josephine. She looked clearly unwell. Jesse caught Hyrum's gaze and gave him a look of bewildered disapproval. He lowered his head further.

Bud then appeared with Clara from a door behind the font. He was enormous in size compared to her. Both were dressed in all white mechanic-like one-piece suits. Bud's suit barely contained his bulging stomach. Clara looked luminous. She waved to her mother then stood on her toes and put her hand above her eyes to block the overhead light to peer carefully around the crowd for her father. Her short auburn hair glowed in the overhead lighting. She found him after a few seconds and gave a smile of relief and happiness.

In an effort not to draw attention to himself, Bud hurried awkwardly down the font's stairs into the water. He slipped, reached for and missed the handrail, and blurted out, 'Oh shit!' before plunging sideways into the font. The resulting wave of water splashed the young onlookers. Some erupted in sobs and got up to seek the help of their parents. Others broke out in laughter and sat where they were comparing their relative

Born Again

wetness. The adults near the font helped the children and kept their amusement to a low mumble. The bishop could be seen with his hand over his eyes shaking his head. He composed himself and did his best to quiet the crowd and bring a reverent tone back to the ceremony.

Bud stood waist-deep in the water, his face bright red with embarrassment. He turned and raised his arms toward Clara to encourage her into the font. Clara stood with her hand over her mouth. It was difficult to tell if she was hiding laughter or an expression of shock. She nodded to Bud and made her way into the font with the assistance of the handrail and his arms.

Facing the crowd and standing chest deep in the water, Clara held on to Bud's outstretched left arm while he raised and squared his right. He looked to Bishop Hafen who gave him the nod to go ahead. Bud began with 'Clara James, in the name of Jesus Christ…'

Hyrum began to quietly cry. It wasn't that he felt the spark of belief; rather he felt a wave of deep love, appreciation, and gratitude for Clara as a daughter and a unique fellow human being. He saw the stretch of time from Clara's earliest years to the remarkable person before him. Further beyond, he perceived Clara as the intelligent, independent, and beautiful woman she would become. She looked just like the remembered image he had of his own mother. Peter put his hand on Hyrum's shoulder and Merle whispered, 'Hey brother, it's alright.'

As Bud carefully enunciated each word of the baptismal prayer in an effort not to bungle the ceremony further, it struck Hyrum that the ordinance seemed rooted further back in the history of humanity than John the Baptist in Judea, Hindu bathing in the mighty Ganges, or ritual washing before Mosque. Watching Clara's submersion and emergence from the water he saw the deeper symbolism of humankind's aquatic origin and ancestral

advent from the great oceans. Hyrum considered the deeper symbolism and beheld the ordinance as something strikingly beautiful and connected to humanity's collective past.

The ordeal, like Peter had said, was over before Hyrum knew it. Clara and Bud emerged carefully out of the font and departed through the door they entered to dry off and change their clothing. The Bishop reminded the onlookers about the importance of Clara's upcoming confirmation where she would 'receive the Holy Spirit through a prayer offered by select men of the church.' Hyrum again felt shamed. The 'select men' referred to were supposed to be Hyrum, who would lead the prayer, the Bishop, his councilors, and other worthy males from the group of family and friends. Because of Hyrum's fallen state, Jesse's father Herb was asked to conduct the prayer. The confirmation would take place the following day as part of the Sunday church services.

People began filing out of the room. Hyrum, Peter, and the LeByron brothers stayed where they were so that Hyrum wouldn't have to deal with the inevitable mingling that would take place in the foyer. Peter talked with the LeByron's about the hunt. Hyrum looked to his left toward the door. As he did, Josephine caught his eye. She shot her condemning, brown-eyed glance and shook her head.

Clara knew that Hyrum wouldn't be attending the baptismal luncheon at Jesse's folks' house afterwards. When he'd asked her earlier in the week if she was ok with this, she said it was fine and that she understood. She revealed that she was most interested in her grandma's deviled eggs anyway.

With the room empty the four men began making their way to the foyer. 'Where the hell are you goin'?,' Cimmeron questioned, 'There's a back door just around the corner. I never use that front door.' Hyrum was much relieved at the thought of

Born Again

an alternative exit. As the men parted in the parking lot, Hyrum noticed that Cimmeron's limp looked for the worse.

'Thanks for coming with me today Dad,' Hyrum said gratefully.

'Like Cimmeron said, I wouldn't miss it. Are you ok?'

'Yeah, I just need to get out of here. I'm tired of all the judgment and shame,' Hyrum replied. 'I tend to lose faith in myself. Most days it feels like I'm drowning in a sea of uncertainty.'

'Don't worry about that Hyrum. Uncertainty is one of the beauties of life. That's why we spend our lives inquiring.'

'But why does everyone act like they've already figured it out and then look down on others who don't?'

'I think it's easier to take comfort in a simple belief system than it is to carefully examine one's knowledge and place in the cosmos. I think we get closer to the truth when we are not already convinced that we've found it.'

Hyrum stood quietly and listened to his father's words.

Peter placed his hand on Hyrum's shoulder.

'Hang in there son.'

'Thanks again Dad. It means a lot,' he said, pausing.

'You care to go hunting with me this afternoon?'

'I think I'm going to need to head over to Bud's and console him after what happened with him falling into the font. Plus, I'm getting a bit too old to go out hunting in this cold.'

Hyrum dropped his dad at his house a few blocks away. Driving home, he made a mental inventory of the items he'd need for the afternoon's hunt. As he pulled into his driveway, he looked for the jay in the old oak tree. She wasn't there. He gathered his things and then drove north on Highway 89 to Juniper Mountain to find the buck.

A Novel

For God so loved the world, that he gave his only begotten Son, that whosoever believeth in him should not perish, but have everlasting life. – John 3:16

12.

Hyrum knew the hills were swarming with hunters, and he wondered if anyone had discovered his particular canyon. He'd been far too busy to return to the area for further scouting over the course of the week and hoped that the buck was still wandering Juniper Mountain. As far as he knew, no rumors had percolated into Butte about the felling of the great animal.

While tempting, it didn't seem appropriate to make a quick stop for beer at Lee's following Clara's baptism. Hyrum knew that the ensuing scandal from such a deed would leave him in an irredeemable position in the community. He turned west at the junction and began the steady climb up the foothills to Juniper Mountain. A light snow began to fall, and he instinctively zipped up his jacket, pulled over, and put the truck in four-wheel drive.

Born Again
The thought of sitting quietly amongst the Ponderosa and Juniper, taking in the thin and fragrant mountain air, diminished his anxiety and brought him a needed calm.

By the time Hyrum turned north on the narrow dirt road the snow had begun to fall more heavily and accumulate on the branches of the stately trees and the dry earth. He drove deliberately so as not to slide off the steep road. Reaching the turnout, he shut off the truck and grabbed his granddad's Springfield rifle, his loaded rucksack, and the half empty bottle of whiskey. Making his way through the scrub oak, Hyrum worried that the buck might have already moved south in the unseasonably cold weather.

After some ten minutes he arrived at the canyon. He paused at its mouth and listened. The snow made a graceful sound as it settled on the branches of juniper and the forest floor. While difficult to discern, he could make out the familiar deer paths and spots where the animals had bedded down. These appeared to be fresh. Hyrum made a careful assessment of the area and decided to take his post a hundred yards away on an upper hillside of the canyon where a good vantage point could be had beneath an old ponderosa.

He sat on his haunches on the dry needle bed under the snow-covered branches with his back to the tree and quietly made ready by loading the rifle, cleaning the scope, situating his binoculars around his neck, and putting on his gloves and hat. Scanning the canyon below, he imagined the happenings at the baptism luncheon. Herb would be barking orders from his wheelchair while his daughter Jesse and his wife Diane scurried around making sure that everything was in its right place and that everyone was happy. Elder Smith would stand around awkwardly wishing he were out hunting with the rest of the men of Butte. The children would run around in their Sunday best putting

A Novel

Diana's two Schnauzers in frenzy while Clara quietly sat at the counter fielding occasional compliments about the baptism and eating deviled eggs.

Hyrum felt immensely proud of Clara for her lucid outlook and pragmatic approach to the baptism. While all of that put him somewhat at ease about her relationships and the Church in her immediate future, he worried about how she'd navigate the difficult waters ahead as she grew older and more independent. One didn't have to look far to find that the cultural pressures to conform were cleverly arranged to ensnare the next generation.

Hyrum couldn't help but feel apprehensive much of the time, and his worrying had grown acute as of late. He understood that the heightened anxiety had helped to lay the foundation for his recent forays with alcohol. He pulled the whiskey out of the pack and took a drink. It warmed his stomach and further took the edge off his stress. He laughed to stop himself crying. 'Stop taking yourself so Goddamned seriously,' he muttered shaking his head. He tried to breathe slowly and deliberately and to take in the quiet calm around him. His mind again drifted back to his own precarious position in Butte, and he worried that things as they stood weren't sustainable. He felt trapped and without a viable escape route. Hyrum admired Cimarron for his willingness to speak out when it seemed least appropriate and to tell the truth. 'Man, that would feel good,' he thought to himself. He wondered how he'd continue to keep composed without rupturing.

Out of the corner of his eye he detected a movement in the north end of the canyon. He slowly set the bottle down and held the binoculars to his eyes.

'One, two, three. Four. Five ... six,' he slowly counted to himself, seeing the does meander around the scrub oak in a single file line.

Born Again

'Seven, eight, nine, ten. Eleven, twelve,' he continued. 'Thirt, thir...,' he said, cutting off slowly upon seeing the creature.

'Jesus,' he paused. 'Jesus, can it be?'

The buck wandered slowly and assuredly at the end of his harem train. He stood at twice the height of the other animals. Appearing alert but tired, the animal walked dream-like through the canyon.

Hyrum breathed slowly, lowered his binoculars to his chest, carefully lifted the rifle from his lap, and raised the scope to his right eye while closing his left. The animals paused momentarily, as if somehow sensing Hyrum's raising heart rate, but then commenced their southerly journey.

A minute adjustment to the sensitive scope brought the buck into focus again. Hyrum gently pointed the end of the rifle barrel to his right, plotting the best spot to make a shot. At his current location, he estimated that he would get his most clear shot through the trees in the coming seconds. After that, he'd have to move from his sub-arboreal vantage point to another while trying not to spook the deer. Given his proximity to the animals and the stillness of the moment, moving unnoticed seemed highly unlikely.

Recalibrating the rifle's trajectory on the herd, Hyrum held his breath, and brought the sights onto the buck. The animal disappeared behind the trunk of a ponderosa that came into view about ten yards from where he sat. He waited for the buck to emerge on the other side. This took what seemed to be an inordinate amount of time. He despaired, thinking the animal had outwitted him or had simply disappeared behind the brush.

He kept his sights fixed on the right side of the tree where he expected the buck to emerge and focused on steadying his hands. His finger held the trigger. Two does emerged, then another two. The herd continued its saunter. More does passed by the scope's sights. Hyrum caught a glimpse of the massive rack of antlers, but

A Novel

a doe that had doubled back to momentarily brush up against the buck obscured the shot. The doe turned again and bounded ahead of the buck; Hyrum took a rapid aim and pulled the trigger.

The gun rang out and ponderosa bark burst into the air. The bullet had grazed the right side of the tree. Hyrum cursed and crawled out from his hiding spot. He could see the animals scattering both up and down the canyon. 'Son of a bitch,' he muttered to himself, sliding his way down the hillside to the canyon floor with rifle in hand and whiskey in his pocket. 'I'm such a fucking idiot!'

Berating himself, he suddenly froze and nearly fell. He heard a loud wheezing behind a stand of ponderosa only twenty yards away. His heart pounded and his throat constricted. He dropped the bottle and made ready with his rifle.

'What did I hit?' he thought to himself as he followed the sound. He walked slowly around the ponderosa and expected to see a doe lying on the ground. He jumped back and slipped sideways on the ground at the site of the enormous buck. The noble animal stood in a small opening. Its stature gave it an otherworldly presence. Steam billowed from its nostrils while blood flowed profusely from its right shoulder and chest. As Hyrum scurried clumsily back to his feet and readied his rifle, the deer turned its stately gaze toward Hyrum. It was suffocating. Before he had a chance to shoot, the animal collapsed on its front quarters, attempted to stand again, and then teetered in woeful resignation onto its side. Hyrum lowered the gun and raised a hand to his mouth as he witnessed the great creature's collapse.

The deer continued to wheeze. Its eyes darted around as if searching for an explanation. As Hyrum approached, the creature shuddered. Inching forward with rifle at his side, Hyrum kneeled slowly in the snow some six feet from the buck's massive head. He stared into the animal's large brown eyes and began to feel

Born Again
lightheaded. A vision of Jesse's face flashed before him. He shook his head to clear his mind, but she returned immediately. Her arresting brown eyes looked through him.

A sudden sorrow washed over him, and he dropped his chin to his chest. His eyes welled as he slowly shook his head back and forth, still peering downward. Raising his head, he looked again into the dying eyes of the great deer. Now he saw Josephine. Her tired brown eyes were afraid and filled with remorse. They beckoned him for reconciliation. He nodded a signal of understanding to the buck.

Looking again, Hyrum saw himself, a lost man. He raised his head to the sky, stared into the falling snow, and felt he was hurling uncontrolled through the great void of space. He glided past the snowy comets and stars at dizzying speeds. The impression was so disorienting that his body began sway, feel light, and become detached from the earth. Panic set in as he thought of his mother Clara and imagined her own mental vertigo before she took her life. He closed his eyes and began to sob. He rocked back and forth as the snow alighted on his face. He raised his hands to the heavens and called out for her.

His daughter's serine face materialized in his mind's eye. It dawned on him that if he was to continue to be a present and stable father for his Clara, he must find a way to better navigate his troubled path. He lowered his arms from the sky and brought his gaze again to the buck. It lay dead and expressionless. The creature was covered in crimson and white. Blood stained the snow for several feet around its head. A profound remorse and humility pressed on Hyrum's chest.

He thought about his students, the class discussion on Buddhism, and the nature of human desire. Why had he and every other male in Butte so desperately wanted to bring this noble animal's life to an end? Was it a deep-seated jealousy about the

animal being wild and unencumbered? Was it to shore up his pride and garner the envy of the community? While he savored venison, he certainly wasn't in need. He had a whole chest freezer full of deer.

He thought again of Hamlet. 'What a piece of work is a man,' he muttered to himself sarcastically. 'How noble in reason,' he carried on, wiping the snow melt from his face, 'how infinite in faculties . . . the beauty of the world, the paragon of animals.'

'What a bunch of bullshit,' he said shaking his head. 'I'm a Goddamned fool.'

He gazed upon the poor animal again. It looked tired and relieved to have been brought down. It too had found itself mired in the relentless crosshairs of life.

He stood up, retrieved the whiskey bottle, drew the rope from his backpack, and methodically tied up the deer's back legs while looking overhead for a suitable branch. His thoughts shifted in between the necessary and unpleasant disemboweling routine ahead and how he'd live his life anew. It took all of his strength to drag the creature to the nearest ponderosa and to hoist it up for gutting. He threw the rope end over a suitable branch about twelve feet up, pivoted, squared his shoulders, and leaned hard on the rope to raise the bleeding body off the ground. He groaned with each outward breath. The rope tore into his shoulder as he jerked the heavy beast slowly upward in fits and starts. 'Goddammit' he moaned, his chest heaving. Sweat ran down his back and cheeks.

Hyrum staggered twice around the tree to tie it off. He caught his breath, wiped his forehead with his sleeve, took a long drink of water followed by a shot of whiskey, and drew his buck knife. The body was suspended awkwardly from the ponderosa with the deer's head and antlers still lying in the snow. He paused before reaching up and carefully piercing the animal's mid-section to

Born Again

release the intestines. The bloody mass slid heavily to the ground. Hyrum leaned his head gently against the hollowed out deer and felt his own gravity shift and lighten. He wrapped his arms around the creature's body to keep from falling. 'I am Hyrum,' he heard himself utter. He recalled Eustace's words about what it means to transcend. 'It's when you rise above things,' he heard her say casually.

Hyrum was born again.

'I've been saved by a deer,' he stated resolutely as he steadied himself for the chore ahead.

'I will make things right.'

A Novel

But he that doeth truth cometh to the light, that his deeds may be made manifest, that they are wrought in God. – John 3:21

13.

It took Hyrum the better part of four hours to clean the deer, cut it into transportable parts, and to haul it bit by bit through the ponderosa, juniper, and scrub oak back to his truck. The path between the deer and the truck became well worn, bloodied, and littered with deer hair. By the time the ordeal was finished, Hyrum and his Carhartt jacket looked and smelt worse for the wear. He covered the animal in back of the truck carefully with a gray tarp. To avoid the massive spiny antlers puncturing the tough fabric or rolling around and breaking his back window, he strapped the deer's massive neck and head to the driver's side corner of the back of the truck bed. Sitting propped up as it was, the creature

Born Again

looked noble but weary, like a beauty queen at the end of a long parade.

 He judiciously made his way back along the narrow dirt road. The snow had accumulated a good eight inches and continued its heavy fall. Stopping before turning left towards Lee's Junction, two trucks of hunters approached slowly on the snow-covered road. The driver of the first truck craned his neck and hit the brakes at the sight of the massive deer head protruding from the back of Hyrum's truck. The passing vehicle nearly slid off the road. Hyrum recognized the driver; a local named Todd Jensen, and could see his three teenaged boys squirming in their seats attempting to get a good look. The second truck slid out to avoid the first. Hyrum could see the driver, Todd's cousin Blaine, uttering curse words at Todd with a fist in the air. But as his truck slid sideways in front of Hyrum, Blaine too caught sight of the enormous creature. He sat stunned with mouth ajar gaping at the antlers. Emerging from his temporary stupor, Blaine snapped his head to the right, made several jerky corrections with both hands now on the wheel, and fortunately righted the vehicle without smashing into Todd. Both trucks then got back into the designated lane and crept forward off Juniper Mountain. Hyrum gave them a moment to get a bit further down the road before turning left and following their tracks off the mountain. He knew it would be only a matter of hours before the whole town of Butte knew that the great buck had been felled.

 Hyrum made it to Lee's as night began to fall. He pulled in to fill up his truck and grab another bottle of whiskey. He knew he was in for a long and cold evening of processing the buck in his garage, and the thought of whiskey warming the stomach sounded nice. He'd decided that he'd no longer hide his Jack Mormon ways, even if it meant buying alcohol on the same day as

his daughter's baptism. For the first time since his early childhood Hyrum felt self-confident.

Walking into Lee's, he immediately noticed how small the rest of the deer mounts appeared compared to the buck in the back of his truck. Nobody stood behind the counter and the store was quiet. He walked over to the cordoned off area in the back of the store and passed under the neon pink liquor sign. Reaching down for a bottle of whiskey, a bell rang signaling the opening of the front door. Hyrum flinched out of habit and chuckled to himself. 'The hell with it,' he said to himself. He grabbed the whiskey with a firm hand and walked honestly to the coffee counter. He poured himself a cup in Styrofoam and added bags of artificial creamer and sugar. The hot coffee tasted of stale, sweet dirt. He topped up the cup, placed a to-go lid on top, and walked to the counter with the coffee and whiskey in hand.

The squat and spectacled late middle-aged owner of Lee's busied himself behind the counter. He looked up to see Hyrum approaching and smiled broadly. Hyrum nodded and put his drinks on the counter. The man had a graying ponytail and smelt strongly of cigarettes. Hyrum deduced that he must have been outside having a smoke and had triggered the bell as he came in.

'Is that what I think it is?' the man said in his Californian accent, looking Hyrum in the eye.

'The whiskey?' Hyrum replied, taken aback.

'Oh, no, no sir,' the owner said, embarrassed. He paused, leaned forward, and braced himself on the counter, 'The deer,' he said slowly with eyes wide, 'I meant the deer.'

'I don't think we've met. I'm Hyrum James,' Hyrum said, extending his hand with a warm smile.

'Forgive me. McGill, Larry McGill,' he said, sheepishly gripping Hyrum's hand.

'Nice to make your acquaintance Mr. McGill,' Hyrum replied.

Born Again

'The pleasure's mine, and please, call me Larry.'

'Well all right, Larry. To answer your question, indeed it is.' Hyrum replied looking out the window toward his floodlit truck. 'I shot him just this afternoon.'

'Good God,' Larry said reverently, looking out the window. 'I knew it! I've never seen such a gigantic deer,' he said with his voice trailing off. 'How in the hell did you hoist that thing into your truck?'

'Well, I had to cut him up and haul him,' Hyrum started, pointing to blood on his jacket.

Larry gawked at the bloodstained jacket like a visitor at a national park beholding a wild animal. He knew in an instant that this single item was a metaphor for what separated him from the people of Butte. He felt a twinge of longing to live like a local.

'Say,' Larry said in dazed wonderment, 'what would you think about letting me pay to have that deer mounted so that it can hang here at Lee's? You know, people would come from all over the place to see that thing. You'd be doing this whole area a big favor.'

Hyrum looked again towards his truck and ran his hand over his lower jaw, as he was prone to do. He thought about how the enormous mount wouldn't really fit in his small living room. It also felt wrong to make a personal trophy out of a creature that had taught him so much. The notion that the deer could be a source of communal pride and gathering at Lee's sounded sensible. The answer came quickly. He nodded his head and said, 'Sure. Why not?'

'That'd be tremendous!' McGill said with genuine appreciation. 'Would you mind dropping it over at the taxidermy? I'll give Bob a call and let him know you'll be coming around.'

'It's no problem, Larry. I'd be glad to,' Hyrum said as he readied to pay for his goods.

A Novel

'This time it's on me, Hyrum,' Larry replied, holding a raised hand in objection to the bills Hyrum offered.

'That wouldn't be right,' Hyrum protested.

'Look, I stand to personally gain from that deer mount,' Larry insisted.

'Yes, but it'll cost a small fortune to mount that thing,' Hyrum replied.

Desperately wanting to thank the humble cowboy, Larry pleaded, 'look, it'd be just a small token of my gratitude.'

'There's really no need for that Larry,' Hyrum said. He paused and looked at the truck, 'If I'm to be honest, I see it this way. If I take your goods without paying, I would be placing a value on that noble creature's head, and I just can't do that.'

Larry admired Hyrum's morals. He nodded his defeat respectfully.

'I know you're grateful,' Hyrum said, reaching out his hand again in a gesture of kindheartedness and generosity.

As the two shook hands, Larry joked, 'the coffee's free with a fill up. Or do you insist on paying for that as well?'

'Not a chance,' Hyrum said, smiling warmly.

After paying for the fuel and whiskey, Larry watched Hyrum make his way to his Chevy truck and drive off toward Butte.

'They just don't make them like that anymore,' he thought to himself, feeling moved by the interaction. 'My friends in California would never believe that people like him exist. That there is a real man,' he said wistfully.

'You've got to love Utah.'

Born Again

The Father loveth the Son, and hath given all things into his hand.
— John 3:3

14.

Hyrum was glad to see the light on at Bob's Taxidermy. He figured that Larry must have rung ahead, and Bob, ornery as he is, agreed to stay open late for the arrival of the gigantic buck. Walking out of the shop just as Hyrum turned off his headlights, the lean and dour man walked past the truck's passenger door to get a look at the deer. Ignoring Hyrum, he put his hands on his hips and muttered several expletives. He approached the deer angrily a half dozen times from different angles with his taxidermist's eyes to size the creature up. It would be the largest deer Bob or his father Cliven before him had ever worked with, he was sure of that much. Hyrum deduced that Bob wasn't happy, especially about having such a time consuming project.

A Novel

'Well, I wish I hadn't kept the shop open,' he said dryly, finally acknowledging Hyrum.

'Sorry about this Bob,' Hyrum said.

Bob raised his eyes from a small notebook he'd retrieved from his flannel shirt pocket. He was scribbling numbers and appeared irritated at the interruption. A couple minutes of awkward silence passed as Bob made his calculations. He then proceeded to tell Hyrum that mounting the deer would be a 'big job' and that 'Larry had better be prepared to pay the bill'.

Hyrum nodded and said, 'I'm sure he will Bob.'

'Seein' that we're early on in the season,' he said begrudgingly, 'I don't have any big projects pressing in on me. Ol' Mable has got me workin' on a whole menagerie of squirrels, birds, and rabbits that she shot with her .22 in her back yard. She's creatin' some damn western naturama scene with rocks, brush, paint, and the hole nine yards on her living room wall. I think she got bored when ol' Vernon died a year ago. He'd be turning in his grave if he knew about it.'

Hyrum gave a bewildered nod and, in an effort to be agreeable, said, 'Yeah, I bet he would. But we all have our own ways of dealing with . . .'

'Well,' Bob said, cutting Hyrum short, 'I'll let Larry know when I've finished the mount. Should take me about a week. Tell you what; I wouldn't have given this deer to no Californian the way you did. Damn outsiders are takin' this place to Hell.'

At that, Bob adjusted his cowboy hat, turned and went back into his shop. Hyrum chuckled to himself and shook his head. Opening the door to his truck to leave, he muttered, 'I suppose when one spends more time with the dead than the living, one comes to be a bit odd.'

Arriving at home, Hyrum rang his Dad to let him know the news and to ask for a hand in processing the deer. Peter had

Born Again

already begun to settle in for the evening with book in hand and a fire in the wood stove. But not being the kind of man to turn down spending time with his son, he put on his work clothes and drove the few blocks to Hyrum's small stone house. He'd thought about his son's predicament for much of the long day and wondered at the remarkable similarity of their lives.

'Ok, let's see this thing,' Peter said, walking into the open garage.

'Hey, thanks for coming Dad,' Hyrum said, readying his things.

Hyrum had placed the tarp on the garage floor and had dragged the bulky pieces of the deer thereon. He'd converted his woodworking area into a butcher's table with the necessary items – including the bottle of whiskey and two mugs. He poured some whiskey and handed his dad a mug.

'Geeze Hyrum, what'd you do to this thing?'

'The damn thing was so big that I couldn't haul it out in one piece.'

'I can see that, but this scene looks like a damn horror movie.'

They laughed and sipped their whiskeys.

'How's Uncle Bud doing?" Hyrum asked with a wide grin on his face. 'It's not every day that someone slips sideways into a baptismal font in front of the community.'

'Oh, it took him a good long while to settle down this afternoon. He wasn't too happy with either of us to be honest. He repeated at least three times that he was 'done being the worthy and responsible male in the family'. LaVerne was ruthless. She kept chiding him for being such a 'clumsy buffoon' during the sacred ordinance. At least she was realistic in saying that folks in Butte would be talking about the baptism for many years to come.'

'If you ask me,' Peter carried on, 'these are the good things of life.'

A Novel

'By the way, where in the hell is this poor creature's head,' Peter said, asking the obvious.

'I'll tell you all about it Dad. Let's get to work before it gets too late.'

As they worked Hyrum recalled the details of the hunt, his moments of rapturous epiphany, and what became of the deer's head.

'I knew you'd untangle it all son,' Peter said.

'You did? I sure didn't,' Hyrum replied.

'Some days I wish there were easy solutions that we could simply package up and give to another, but there aren't,' Peter reflected. 'There's no one-size-fits-all to life. The real answers have to come from within, from the deepest recesses – from the twinkle of light at the bottom of the well. This seems to be the first of life's great struggles, to peel back the social conventions and impulses of fear, guilt, and avarice that cloud our true selves. We must recognize and work hard to control these profound influences, otherwise they have immense leverage over us.' He paused and thought. 'The second of life's great problems, which is tied to the first, is to ponder upon our talents and capacities, our values and goals. These are the threads of that unique fabric that weave our true identities. This, it seems to me, is how we clear the path in our search for meaning and purpose.'

Hyrum saw that Peter's eyes were bright and crystalline. His demeanor radiated with hope, kindness, and humanity.

'One thing is for damn sure,' Peter spoke on, 'all of this takes hard work and relationships sustained by generosity and humility. But the payoff is to live, love, flourish, and be fulfilled.'

Hyrum felt the beauty of his father's salient words. He responded with, 'I now know, Dad. But it's a difficult journey.'

'Yes it is,' Peter responded, 'but you know Russell was right when he said that 'most people would rather die than think, and

Born Again

most people do.' Yeah, it's easier to live a second hand life where we simply adopt the views and beliefs of others, but that life won't be your own.'

As they wrapped up their work, Peter could see his boy teetering towards exhaustion. With Clara's baptism, the hunt, and organizing the body of the slain deer, it had been a momentous day. It took three hours to butcher the deer and carefully pack the meat. As Peter placed the last of the deer into the spare chest freezer in the house, Hyrum tidied the garage.

Walking back into the garage, Peter embraced his son. They both smelt of whiskey and blood.

'I'm so proud of you boy,' he said, grasping Hyrum's shoulders.

'Thanks for always being here for me Dad. I mean it, really,' Hyrum said looking his father in the eyes.

'Son, if we didn't have love and companionship we'd be poor creatures indeed,' Peter replied.

Hyrum watched his father walk slowly to his truck. Peter looked weathered, wizened, and full of good spirits. Hyrum felt grateful to have been brought up and cared for by such a man.

That night Hyrum slept more serenely and restfully than he had in years. He dreamt again of the buck. The regal creature meandered with grace and dignity through the canyons, trees, and scrub of the high desert until it stood on the edge of a towering white cliff.

Hyrum awoke in the late morning with the eastern sun resting upon his face, seeming to instruct him. The Sunday before him would indeed be a hallowed day, when the world would be made whole again. He had a clear impression of what he had to do.

A Novel

For God sent not his Son into the world to condemn the world; but that the world through him might be saved. – John 3:17

15.

Having been caught up in Saturday's colossal events, Hyrum had forgotten to eat. He climbed out of bed and stared out the window at the snow-covered landscape. The sunlight sparkled unencumbered and illuminated icicles hung polychromatic. He felt serene but weak. He took a long hot shower and made himself an enormous breakfast of eggs, toast, bacon, beans, and coffee. Old country songs crackled on the AM radio as he ate. He didn't read the paper or flip through his hunting magazines to pass the time.

Born Again
Instead, he sat as if seeing the world anew. While he'd always been an observer of things, Hyrum now felt his senses amplified many times over. He savored the exquisite flavors of the food, rejoiced at the simple harmonies of the songs, and laughed out loud at the marvelous taste of the coffee.

Feeling fortified and grounded, Hyrum proceeded to transfer all of the freshly packed deer venison from his chest freezer to three camping coolers. These he placed in the back of his truck. Looking at his watch, he realized that sacrament meeting would be just getting started at the church house. Today Clara would be blessed and confirmed with the Holy Spirit by Jesse's father Herb. Leaning against the truck, Hyrum recalled when Uncle Bud and the elders of the church had confirmed the spirit upon him many years ago. Solemn hands had felt heavy on his head, and he realized that he had carried that heaviness for the better part of twenty years. This morning his body felt light, and his mind liberated.

Hyrum got in his truck and drove north out of town on highway 89. He knew that Jesse would chide him for not attending Clara's confirmation at the church house. But that didn't seem to bother him now. He focused instead on the luminescent snow covered landscape. The tangerine limestone of the upper hills seemed illuminated from within. The stands of autumn maple, squat Juniper, and yellow Manzanita looked of complexly frosted Christmas candies. He contemplated the visual feast and was drawn into a near trance of sublime beauty. For the first time in his life he felt full.

Hyrum felt an overwhelming appreciation and love for his fellows. It was for this reason that he drove north. Turning off the highway five miles out of town, he put the truck in 4-wheel-drive and drove east into the foothills of the Paunsaugunt Plateau. The poorly maintained dirt road took some careful navigating in the snow. He now understood why Merle's truck and trailer was so

A Novel

battered. After several forbidding switchbacks and steep climbs he heard dogs barking. Rounding the last corner, the old LeByron homestead came into view. Two large dogs lifted themselves resentfully from the porch of the small rustic log cabin and noisily approached the truck. Pulling in, Hyrum looked at the smoke rising from the chimney, the old rusted machines, fuel tanks, and untidy piles of wood surrounding the place. He was glad to see Merle's old '82 Ford parked underneath a makeshift lean-to made of scraggly Juniper and old tin siding.

The door to the cabin drew open and Cimarron hobbled out. Squinting into the sun, he looked at Hyrum's truck suspiciously. Only after recognizing Hyrum in the driver's seat did he call off the dogs. The larger of the animals, a gray and black shaggy mutt with one eye, refused to heel. Cimarron attempted to give it a kick with his good leg, but sensing the approach of his master, the dog jumped out of the way at the last minute with a loud yelp. As Hyrum rolled down his window, Cimarron clumsily recovered himself on the hood of Hyrum's truck.

'Goddamn dog!' Cimarron muttered. 'Damn thing dudn't listen for shit!' he said, approaching the window.

'Well I'll be damned!' Cimarron said, generously extending his hand through the window.

'Hello there, Cimarron,' Hyrum replied, taking Cimarron's firm grip.

'What the hell brings you up here, Hyrum?'

'I've got something for you and Merle,' he said, shutting off the engine.

'Is that so?' Cimarron replied, taken a back.

'Shit, it must have been some ten years since we had a visitor here at the ranch. We can't even get the damn UPS guy to drive up our road anymore. Last time he did, he nearly rolled that truck off the mountain!' he said gleefully. 'Merle had to winch him up to

save him from teeterin' off the edge of one of them there switchbacks.'

'Yeah, that road isn't for the faint of spirit,' Hyrum chuckled.

'Say, why don't you come in for a cup of coffee.'

'That'd be real nice,' Hyrum replied.

'Good!' Cimarron said, nodding a gesture of approval. He slapped the hood of the truck and began to stagger back to the cabin.

Hyrum hopped out of the truck and savored the aromatic mountain air laced as it was with wood smoke from the cabin. He zipped up his jacket and retrieved one of the coolers from the back of the truck.

From the cabin door Merle saw Hyrum straining under the cooler's weight.

'Wait there just a minute young man,' he called out, walking towards the truck. 'Let me give you a hand with that.'

Merle gave Hyrum a hearty welcome to the homestead and helped him carry the cooler to the cabin.

'So, what you got there?' Cimarron said, pouring mugs of coffee.

'It's just a little something for you guys,' Hyrum replied, taking in the well-worn surroundings of the Spartan cabin.

The men sat at the small wooden table hewn by an ancestor LeByron and drank their coffee as Hyrum told them the tale of shooting the trophy buck.

'Well hot damn,' Cimmeron said, reflecting on the story. 'Ain't that somethin'?'

'If that ole buck had to be got,' he carried on, 'I'm damn glad it was got by you rather than Smithy, Hafen, or one of those other self-righteous sons of Lucifer.'

'Well done Hyrum,' Merle nodded. 'It must have been some feat haulin' it out on your own as you did.'

A Novel

Hyrum opened the cooler so the brothers could see the numerous packaged parcels of meat.

'Well, ain't that something?' Merle said, showing signs of emotion. 'I was wonderin' where we'd get our winter meat this year. We've been so busy this autumn deliverin' wood and with Cimarron's troubled leg and all, we've not got out to do our own huntin'. Now with winter settin' in, it's unlikely we'd be able to do so. This is really kind Hyrum.'

Cimarron's eyes had welled up. 'You know, things are different now since the accident,' he said choking up while looking at his feeble leg. 'So, it means a lot brother Hyrum. Thank you kindly brother. Thank you kindly.'

'Look, it's nothing you guys,' Hyrum replied. 'I'm just really grateful for you two looking out for me out in the way you have. It's not everyday that one receives the kind of support you've given me in recent weeks.'

'You can always count on us brother,' Merle replied. 'Would you care for a whiskey?'

'I better pass on the kind offer, Merle. I had enough whiskey yesterday to knock over a horse,' Hyrum said, smiling.

'Suit yourself,' Cimarron said, attempting to get up.

Merle saw his brother struggle to get on his feet. 'Let me get it for you brother,' he said, getting up.

'This damn leg just don't work anymore,' Cimerron complained.

He carried on, 'You know half this town is on some pain killer or drug to make you happy. I reckon that's why people 'round here are so confused. They can't even think straight. After that backhoe smashed my leg, the doctor tried to get me on 'em and I told him to take 'em and stick 'em right up his ass! He didn't like that too much. But I refuse to take them pills.'

93

Born Again

Merle sat a mug of whiskey down in front of Cimerron and put a hand on his brother's shoulder. Cimmeron gulped a large swallow.

'You know it's a damn hypocrisy when half of Mormondom is jacked up on them pills, and I can't even have a drink without bein' judged. If, ole Bishy Hafen says one more thing to me about the drink, I'm gonna throw my flask right at his head!'

'Maybe it'd knock some sense into him!' Hyrum chimed in.

'Hell, I reckon it'd be worth a try!' Merle quipped.

The men unloaded the cooler and filled the LeByron freezer with the meat. Cimarron set about blasting the church leadership in his uncanny and irreverent way.

'Who has the right to tell you that you can't bless or confirm the spirit upon your own daughter?' he demanded of Hyrum without seeking a reply. 'What kinda gumption those debauched, fork-tongued, bastard, telestial apostates must have, huh? It's un-be-live-a-ble!'

Merle shot Hyrum a wink as Cimarron carried on. Hyrum returned the gesture with a hearty smile.

'Saved by sinners,' he thought.

A Novel

*If I have told you earthly things, and ye believed not,
how shall ye believe, if I tell you of heavenly things? – John 3:12*

16.

Hyrum left the LeByron homestead with dogs nipping at his heels and jumping upon his truck. Cimerron uttered futile curses at the animals from the porch demanding they behave better. 'He's one of us you jackasses,' he croaked in vain. As the dogs chased the truck down the road, Hyrum felt rigorously happy. 'What gems those gents are,' he muttered to himself, 'what gems.'

He drove slowly off the plateau and south towards Butte. The sun hung bright in the winter sky. Looking at his watch he saw that church would just be letting out. He hoped to catch Jesse and Clara at Herb's place before they set down to their Sunday mid-afternoon meal with the extended family.

Born Again

Arriving at the circular drive and large, white ranch-style home, Hyrum took note of the numerous new Ford pickup trucks lining the street. The enormous vehicles made his old Chevy look the size of a sedan. He found a place to park and walked up to the house. As he did, Clara flung the house door open and ran to her dad.

'I saw you pull up,' she said, hugging Hyrum in the driveway. 'Is it true?'

'Is what true?' Hyrum replied, holding Clara.

She looked up, 'The deer. Did you get the deer?'

'Yeah, I got the deer,' he said reluctantly.

'Wait,' Clara puzzled, 'are you not glad about it?'

'Well, it's complicated,' he said, running his hand over his mouth.

'What do you mean?' Clara queried.

'It's odd,' he paused. 'It's like I needed it to happen, but I wish it didn't have to happen. Let's just say that I don't think I'll be hunting for some time. We'll have a good talk about it when Mom drops you off later tonight.'

Clara nodded as if she already understood. She looked for signs in her father's eyes. She saw a calm, untroubled, and contented man.

'Did everything go ok with your blessing this morning?' Hyrum asked without his usual tone of apology.

Clara was glad not to hear her father be ashamed.

'Yeah, I suppose so,' she said, looking back at the house. 'The whole thing was a little weird though, especially being surrounded and blessed by smelly old men.' Clara snickered and then looked at her dad with a more serious expression, 'Why is it that all the church stuff is done by a bunch of men anyway?'

A Novel

'That's a good question,' Hyrum replied. 'It used to be that women had a few more rights in the church than they do now. But they've been pushed aside by the men.'

'Mom says that women don't need to have the priesthood or do the church things that the men do because they get to have babies.'

'Yeah, I've heard that argument before and it doesn't seem to make much sense to me.'

'What do you mean?' Clara asked.

'If I told you that the reason men can have the priesthood is because they have penises or hairier bodies than women, you'd say that was crazy, right?'

Feeling embarrassed, Clara laughed and nodded her head

'Well, just because women have a biological ability to have babies, does that mean that they should be excluded from the priesthood?'

'Nope,' she said, shaking her head and pursing her lips. 'That's not right.' Pausing, she carried on, 'Maybe one day women will have the priesthood in our church.'

'I think you're probably right,' Hyrum smiled. 'Some other churches have already done this.'

'That sounds fair,' Clara replied.

He took her hand in his and gave it a squeeze. 'I'm so proud of you kiddo.'

'Thank you very much,' she said in a low register, feigning a man's voice.

'Hey, will you go get your mother for me?' he said, messing her hair, 'I've got something to give her.'

'Yes sir,' she said in her low voice. Skipping back to the house, she called out, 'Just one minute sir.'

Hyrum walked back to the truck to retrieve the second cooler. Struggling under the weight, he turned toward the house to see

Born Again

Jesse standing in the doorway. He lifted his head and nodded at her. She stood with a hand on her hip and didn't respond.

By the time he reached the door he was panting. 'Hello there Jesse,' he offered up.

'Where were you today?' she said curtly, shutting the door behind her.

'I was visiting the LeByron brothers,' he said without reservation.

'The LeByron brothers?' she said incredulously. 'You'd rather spend time with those foul-mouthed drunks than attend your own daughter's confirmation?'

'Unlike the LeByron's, I'm sure Clara was attended to just fine this morning Jesse,' he replied straightly.

'I don't understand you Hyrum,' she said, her anger welling up. 'Aren't you ashamed? Don't you care what others think?'

'Not really' he said calmly. He gave her a sincere smile. 'Please don't worry so much about it all Jesse. Clara's ok with it. I'm happy. I think it's time you let it go.'

'Let it go! And be ... what? Like you?'

'No, not at all. Just be yourself, that's all. Remember when we were young, before we were married? We didn't care so much about this stuff. We lived more freely, passionately, and unconfined. Hell, you were the wild rodeo queen!'

'We were kids Hyrum,' Jesse said, feeling her face flush.

'Perhaps that's what's great about kids. We weren't so concerned about social conventions back then. We laughed a lot, held our beliefs lightly, followed our intuitions, and charted our own course. Now look at us. I can't remember the last time that we've had a positive or caring conversation. We've become so serious and stern. When was the last time you felt truly happy?'

'I'm quite ... I'm very ...' His question struck a chord unexpectedly, and she started to cry.

He set the cooler down.

After a long pause, she said, 'It's been a long time. It's been too long.'

'I'm ready to be done with all this misery,' he said, 'and I hope that you can find it within yourself to overcome it too. It's holding us both back.'

'I've been so stressed it feels like I might explode,' she said, wiping her eyes. Jesse looked out across the drive. 'You know, for a long time I blamed you. You were the one that I could pin all of my frustrations and anger on. It was easier to blame you.'

Hyrum smiled at her empathetically and said 'I'm sorry Jesse.'

'If I'm honest though,' she said, looking upwards and wiping her eyes again, 'I realize that I've got nobody to blame but myself. I've allowed myself to get to this state. Looking Hyrum in the eye, she said, 'I've been jealous of you. I've been jealous that you seem not to care about what everyone thinks.'

'Believe me, I've cared far too much and it's caused me a fair bit of grief,' he said removing his cowboy hat, 'and this gray hair.' He ran his hand through his graying cowlick. 'But I'm done with that now.'

'I don't want to be angry anymore,' she said choking up again, 'and I'm sorry too.'

'You don't need to be. Neither of us need to be,' he said reaching out to her.

The two came together in a warm and caring embrace.

Clara sat at the window watching the interaction between her parents unfold. For the first time in her memory she saw them hug one another. She retrieved a small gray stone from her dress pocket, squeezed it in her hand, and smiled quietly.

'I'm sorry about interrupting your Sunday lunch,' he said, still holding Jesse.

Born Again

'I'd invite you in for a bite to eat, but elder Smith and my Dad might kill you,' she laughed, pulling back.

'That's quite all right Jesse. I've got another errand to run.'

'What's that you got there in the cooler?' she said.

'This is for you. I shot a deer and brought you and Elder Smith some of the meat as an offering of friendship.'

Hyrum opened the cooler and showed Jesse the carefully wrapped white bundles of meat.

'That's really kind Hyrum,' she said taken aback. Her tears began to surface again and she shook her head. 'That's really kind.'

'This must be *the* deer that has everyone talking,' she said smiling through her tears.

'Indeed it is,' he said.

'You're the envy of the town Hyrum.'

'Don't be silly.'

'You are,' she said. 'I think you've taken the wind out of the sails of the men folk around here. A lot of people aren't even bothering to get out for the hunt now. Say, would you mind carrying the cooler to the truck for me? I'd like to put it in my freezer at home before bringing Clara to you this evening.'

'You bet, Jesse,' he said, lifting the cooler and turning to her truck. 'Was Josephine in church today?'

'No, she's too sick to attend. She's got stage four cancer and has less than six weeks to live. Bishop Hafen called for a special fast for her in sacrament meeting. Why'd you ask?'

'Well, I've got one last cooler of meat there in my truck,' he said, motioning over his shoulder, 'I intend to take it to her now.'

'I hate to say this, Hyrum, but she likes you less than just about anyone in town. She'll rip you apart.'

'That's why I intend to see her.'

A Novel

An no man hath ascended up to heaven, but he that came down from heaven, even the Son of man which is in heaven.
— John 3:13

17.

Josephine's small brown rambler house looked gloomy. Pulling up, Hyrum noticed that Walter had largely given up on maintaining the place. Leaves were scattered about in the now patchy snow and yellow grass grew long through the cracks in the cement driveway. Josephine's flower boxes sagged from the windows with their withered gray contents and an asphalt shingle hung loose over the roof's edge. Her maroon Buick sat parked in the carport.

Born Again

Hyrum retrieved the third meat-laden cooler from the back of his truck and walked to the door. The house sat quiet. He set the cooler down and gave the door a firm knock. Inside Josephine sat in her chair, wrapped in her bathrobe. She had seen Hyrum pull up and walk to the door, and her stomach turned over with anxiety.

'What the hell is *he* doing here,' she muttered to herself.

She felt nauseous. The pills the doctors gave to her made her sick and put her in a state of muddled consciousness.

He knocked again.

'Josephine? Are you there?' he called through the door.

'What do you want?' she snapped loudly, not bothering to get up.

'I've come to give you something,' he called back.

'I don't want anything,' she answered.

'Come on Josephine, just let me in.'

The house went quiet again. Hyrum waited. He turned and looked out to the street. He could see the scratch marks from the LeByron dogs on the side of his truck. 'Jeez,' he said to himself.

The door opened abruptly and Hyrum swung around. Josephine stood at the door with a snarled look on her face. Her bathrobe was dirty and her feet were a hue of dark purple. Her maroon hair had largely given away to gray. It looked thin and patchy. Her face was puffy but set with deep wrinkles that led to her recessed brown eyes. Her matronly presence had withered, and she appeared frail and vulnerable.

'What do you want?' she said hoarsely.

'I want to make amends with you,' he implored.

'There's nothing to mend here.'

'Come on Josephine,' he said, looking her in the eye, 'you've not had a nice thing to say about me in ten years. And frankly, I've not been so fond of you either. I want to change that.'

'Don't you think it's a little late for that?' she said sarcastically, looking over her sickly body.

'No, I don't. Can I come in?'

She paused and looked out at the street. 'Suit yourself.'

Hyrum picked up the cooler and waited for her to move aside so that he could enter. The house was dim and smelt of illness. It took him some time to make out where sit. He sat the cooler down and found a spot on the sofa opposite Josephine's chair.

'How you holding up?' he said, sympathetically.

'What does it look like?' she snapped back.

'I'm real sorry that you're sick, Josephine.'

She didn't reply.

'Look, I brought you …' Hyrum started.

'I'm in terrible pain and the only thing these cancer drugs seem to do is make me sick and dizzy,' she interjected.

Hyrum listened.

She was still.

'I've been on pain pills for a long time,' she confessed abruptly.

He sat quietly and looked intently at her.

'It all started with a pain I had in my back about fifteen years ago. But then things got out of control. I've been taking three or four times the dose for years,' she said absently. 'Now, when I need the pills for the pain, the damn things don't do anything for me anymore.'

'I'm real sorry Josephine,' Hyrum said. 'You know I drink now and again,' he said trying to be empathetic.

'I know you do, and I've told everyone. But I think I brought this cancer on myself.'

'With the pills?' he asked.

'Maybe,' she said, pausing. 'My liver is shot. But I suspect it's bigger than that.'

Born Again

'What do you mean?'

'I've been a sinner, and I ...'

'I don't think ...' Hyrum intervened.

'Let me finish,' she said. 'My faith led me to be prideful and ruthless. All along I thought that is what it meant to be good. I've taken pleasure in the pain of others and elevated myself. I've spent my life judging and have been mean spirited. I've alienated everyone that I care about,' she paused, looking blankly toward the window. 'My husband is afraid of me. He spends all of his time out back in the shed. I've been cancerous.' She then turned her gaze to Hyrum. 'That's how I made myself sick.'

'Oh Josephine,' Hyrum said, reaching his hand out to her.

She took his hand. 'Hyrum, give me a blessing. I'm slost. Please pray for my soul,' she said pleadingly.

Taken aback, he said, 'I won't do that Josephine.' He shook his head, 'but I will be your friend.'

'What do you mean you won't give me a blessing!' she said erratically, pulling back.

'Josephine, I won't do it because I don't believe it's the right thing to do. What you need is a real friend who will hear you out and support you in meaningful ways. These blessings throw a wrench into authentic communication where we listen carefully to one another and offer each other support.' He looked down at his boots and then up to search Josephine's face. 'Who else have you told all of this to?'

'No one.'

'No one? Not even your husband? Or Bishop Hafen? What about the women at the hair salon?'

'I've not told anyone,' she said flatly.

'I don't understand. Why have you told me?'

A Novel

'I couldn't tell anyone that I respect or that respected me,' she said bluntly. 'I guess I also figured I'd give you a chance to get back at me for all of the terrible things I've said about you.'

'I'm not interested in that, Josephine. I forgive you,' he said pausing, 'Josephine, I forgive you. Will you forgive me?'

She started to cry. She reached out her hand to him.

'You don't need forgiving,' she sobbed.

'We all do Josephine,' he said, taking her hand. 'It's not that we're sinners, it's just that we must learn to be more kind and full of good will toward one another. We need to recognize the senseless things that cause us to be divided and take the time to know and appreciate one another.'

A long pause ensued. She nodded in acknowledgement.

'As your friend I will come visit you each Sunday afternoon. We'll have open and honest conversations about our lives. I may even bring my daughter Clara along once or twice if that's ok.'

She looked up, hopeful. 'I'd like that a lot,' she replied.

'Do you feel a little better Josephine?' he asked.

'I do,' she replied.

'As a token of our friendship, I've brought you this meat. I shot this deer yesterday and have wrapped these parcels up. I would like to put them in your chest freezer.'

'I can't take it from you Hyrum.'

'Why not?'

'I can't eat it. My stomach won't tolerate it.'

'I'm sure Walter would like it then,' Hyrum implored.

'He might, but he needs an excuse to get out of here for a few days to go shoot a deer of his own. He plans on going hunting tomorrow.'

'But I thought ...' he said absently, running his fingers over the top of the cooler.

'You thought what?' she asked.

Born Again

'Oh, it's nothing. I just thought I needed to bring this meat to you.'

'You know who could use this meat?' she interrupted. 'The Navajo woman that I work with at Lee's.'

'Emma?'

'That's her. She lives out in Meadow in a trailer with her teenaged son. I think she struggles to put food on the table. As she's not a member of the Church she doesn't get much support from anyone.'

Hyrum ran his hand over his mouth. Josephine was right.

'That's a really good idea,' he said, nodding his head, 'If you don't mind, I think I'll take it to her now. I'm worried this meat will thaw. Can I get you anything Josephine?'

'No, son. But when you come next week bring Clara along.'

'I will,' he said, getting up and placing his hand gently on Josephine's shoulder. 'We'll look forward to it.'

Josephine put her hand on his. 'I've got an apple pie recipe I'd like to share with her.'

A Novel

*He that hath the bride is the bridegroom . . .
my joy therefore is fulfilled. — John 3:29*

18.

Hyrum returned the cooler to the back of the truck and headed out of town again on highway 89. As he drove north, the sun sat low in the over Juniper Mountain. The foothills were lit with ethereal hues of purple, red, and blue.

In the distance Hyrum could make out the large floodlit sign beckoning weary travelers from the surrounding wilderness. He slowed as he approached the Lee's Junction. The lights flickered over the gas pumps and a solitary individual stood inside over the till. Emma's olive green truck was nowhere to be seen.

Born Again

He drove on another two miles into the dusk before pulling off the highway and crossing a cattle guard onto a dirt road that led a short distance to the small settlement of Meadow. The place consisted of a half dozen run down trailers set haphazardly in a circle formation. Junk was scattered here and there, and several broken down cars sat like carcasses in the windswept snow. Dogs barked and people stirred in their trailers as Hyrum drove in.

Emma's truck sat at the far back next to the only tidy trailer in the park. Cottonwood trees and a worn basketball hoop stood around the place. Smoke emerged from a metal chimney. A light was on inside.

Hyrum pulled up and turned off the engine and lights. He retrieved her small spiral notebook from the glove box, slid it into his pocket, and proceeded to get third cooler from the back of the truck. Emma opened the trailer door and called out, 'Can I help you?'

She had seen the truck pull up from the kitchen window and stepped outside to see what was going on.

'Hi Emma. It's me, Hyrum,' he replied, walking up to the house.

'Hyrum? What are you doing here?

'I've come to bring you something.'

'Ok,' she said, puzzled, 'come on in.'

She opened the door wide and Hyrum squeezed through with the cooler.

The immaculately kept trailer caused him to pause with worry that he'd make a mess of something. He stood in his tracks.

'Please, please, have a seat,' Emma said, gesturing toward the small sofa.

Hyrum sat the cooler down and looked at pictures on the wall as he waited.

A Novel

'Sam?' she called out toward the narrow hallway, 'We've got a visitor.'

Sam emerged from his room.

'Sam, Mr. James has come to visit.'

Hyrum turned to shake hands with Sam.

'Hey Sam. I'm sorry to bother the two of you, but I wanted to bring you something,' he said, gesturing to the cooler.

Sam swallowed hard, relieved that he wasn't in trouble with his teacher. Emma took noticed his anxiety and messed his hair. 'Don't worry Sam,' she joked, 'He's not here for school.'

'I know it's a bit odd dropping by,' Hyrum said, sitting down on the sofa, 'but I shot a deer and thought that I'd bring you by some meat for the winter.'

He opened the cooler and showed them the parceled meat inside.

Emma nodded, reached for Sam's hand, and said, 'Wow Hyrum, that's really generous of you.'

'It's nothing. Really,' he replied.

'This must be the deer that Larry was talking about all morning at Lee's.'

'Yes, he's having the head mounted for the store.'

'You know, he's tells everyone who comes in about it. I suspect a bunch of people will be there when he reveals it on Saturday morning.'

'Is that so?' Hyrum said, clearly uncomfortable with the idea. 'Hmmmm. Larry left a message on my phone saying that the mount would be ready Friday evening and that he'd like me to be there at 10:00am on Saturday. He sure is an enthusiastic guy.'

'Yes he is,' Emma said chuckling.

'Hey, what's that you're reading?' Hyrum said, pointing toward the book in Sam's hand.

Born Again

'It's *The Lone Ranger and Tonto Fistfight in Heaven* by Sherman Alexie,' he said, holding up the book. 'My mom got it for me.'

'That Alexie sure does write well,' Hyrum said. 'I really like the way he weaves poetry into his writing.'

'Yeah, a lot of what he says I can relate with. It seems like life for the Spokane is pretty much like life for the Navajo,' Sam said, looking down at the book.

Hyrum nodded. 'Do you miss the reservation?'

'Yeah, my friends are there.' Sam fell silent.

'And are things going ok here with school and everything?'

'Yeah, I like school. And basketball. And reading.'

'Hey, I've got a film called *Smoke Signals* that I think you'd like. Alexie wrote the screenplay for it. I'll bring it to school for you sometime this week.'

'Yeah, I'd like to see it. Thanks.' Sam looked at his mom.

'Yes, you can go,' she said, motioning toward his room with her head.

'Thank you for the meat Mr. James,' Sam said standing up, 'And for the movie.'

'You bet Sam,' Hyrum said, shaking Sam's hand again. 'We'll see you tomorrow then.'

Sam walked to his room. Emma turned and watched him. She then turned towards Hyrum and smiled.

'Let me give you a hand with unloading this,' he said, placing his hand on the cooler.

They each grabbed a side of the heavy box and carried it to the refrigerator. Taking their time placing the parcels of meat in neat stacks in the freezer, Emma discussed their difficult situation on the reservation. Hyrum shared how he had divided up the deer to help mend his world.

A Novel

Their hands grazed twice as they talked and worked. They both liked the sensation and laughed the second time it happened. Placing the last parcel in the now full freezer, Emma asked, 'so what needs mending between us?'

'I'm not sure,' he replied. 'Josephine said I should come here. I suppose I'm here to find out why.'

'I'm really glad you came over,' she said, taking his hand.

He held her hand tightly in his, 'I am too.'

The two smiled and savored the simple moment.

'Hey, I think this is yours,' he said, reaching into his jacket pocket. He handed her the spiral notebook.

'What? Where did you find this?' she said, puzzled.

'I think you left in my classroom the other night,' he said.

'Of course,' she paused. 'You didn't look through it did you?' she said, squinting her eyes playfully and turning her head to the side.

'I may have had a peek,' he confessed.

'Hyrum!' she called out, tapping his chest with the book.

'Are you free anytime this week?' he asked. 'It would be nice to get together for dinner.'

'I'd like that a lot,' she said, placing her free hand in her back pocket. 'Would Friday be ok?'

'Friday would be great,' he said, nodding. He looked down at his watch, 'Hey, I've got to run. Jesse will be dropping Clara off at my place soon.'

Emma reached out and gave Hyrum a generous embrace. 'Thanks for this Hyrum.'

'It's nothing,' he replied. 'I'm already looking forward to Friday.'

'Me too,' she smiled happily.

Born Again

The wind bloweth where it listeth, and thou hearest the sound thereof, but canst not tell whence it cometh, and whither it goeth: so is every one that is born of the Spirit. -John 3:8

19.

Father and daughter spent the next several evenings recounting the events surrounding the hunt and sharing the deer. Clara listened to the stories attentively and asked her usual questions. She felt more at ease then she could remember. The one tension of her life – her parents' troubled relationship – had been ironed out. She put her books down and lay on the sofa smiling, discovering patterns in the textured ceiling. Peering out the window, Clara searched for the anxious jay. The bird was nowhere to be seen.

Hyrum met Emma at Ruby's Inn for dinner on Friday. His nervousness dissipated as they spent the evening drinking wine, holding hands, and chatting about the goings on around Butte. They shared more of their life stories, complained about their

A Novel

jobs, and discussed the challenges of being single parents. As the evening wore on, the impending confluence of their lives became more and more apparent. They savored the initial steps into the unknown they were taking together. The night ended after dessert and coffee on the front steps of Ruby's with an affectionate embrace, an adoring kiss, and Emma inviting Hyrum around to her place the next evening to watch *Smoke Signals*.

Hyrum arrived back home in Butte to a phone message from Larry at Lee's. Larry relayed how the taxidermist had finished the deer mount and how he had spent the whole evening attempting to mount the enormous buck on the wall. 'The pulley system I rigged to hoist the mount broke clean free from the wall under the weight of the damn thing,' Larry said laughing. 'If it weren't for that giant antler rack catching miraculously on the smaller mounts to either side, the thing would have dropped and broke into pieces!'

Larry went on to tell how he eventually fastened the mount to the wall by driving a Bobcat tractor into the store, securing the deer head to the bucket, and lifting it up into place so that he could attach it to the wall. Hyrum laughed at the message and shook his head in disbelief. 'This whole thing ought to be interesting,' he muttered as he gave a cursory glance at a pile of student essays. 'You'll will have to wait,' he said talking to the papers.

Saturday morning found Hyrum in the garage tinkering with the passenger door of his truck. The door had begun to stick some weeks ago, and Clara could no longer open it. She liked that her dad had to let her in or out of the vehicle. 'Thank you sir,' she'd say in a low voice. 'You're welcome miss,' he'd reply in a regal accent.

Hyrum fixed the door and fortified himself with another cup of coffee before making his way to Lee's. He felt a degree of

Born Again

trepidation about the 10:00am gathering and didn't like the idea of being a center of attention. 'I suppose what's done is done,' he thought, driving across town to pick up his father.

'You fixed the door,' Peter commented, getting into the truck.

'I got around to it just this morning.'

'It's about damn time! Well, it's been a big week for you. You ready for this?' he said, slapping his son on the knee.

'I suppose so. It can't be any worse than the baptism the other day.'

'No, this one's not to worry about. You're the envy of the town this time around.'

'Funny how things can turn on a dime like that.'

As father and son drove to Lee's, Hyrum told Peter about using the deer to mend his relationships. He also told him about his date with Emma.

'I knew that once you came to grips with yourself you'd right everything.'

'I suppose that's what it takes,' Hyrum added.

Peter looked at Hyrum and smiled. 'Everything is as it should be. And I'm happy to hear that you've got a thing going with Emma. She seems like a very special person.'

'Well, I think you'll be seeing a lot more of her around,' Hyrum said absently as he approached Lee's.

The Juniper Mountain junction on Highway 89 was lined with trucks parked on both sides of the road. The store parking area was full. Balloons were tied to the gas tanks. Across the front of the store a large banner read 'Come On In And See The Trophy Buck.'

'Oh wow,' Hyrum uttered, looking around for a place to park. 'It looks like Larry went all out.'

Peter laughed. 'This is the biggest thing that's happened in this area for a long time, Hyrum. People need this.'

A Novel

As Hyrum pulled into the parking lot, Larry bolted out of the store waving his arms.

'I think he wants you to park there,' Peter said, motioning to the orange cones blocking the one free parking space in front of the store.

Larry quickly removed the cones and directed Hyrum into the parking spot like an air traffic controller. He gave the men hearty handshakes, slapped Hyrum on the back, and led them into the store. Hyrum adjusted his cowboy hat nervously as he walked in. The crowd in the store erupted with applause. Hyrum gave a wave as Larry led him down the main aisle of the store past the penny candy, sunflower seeds, beef jerky, and neon light.

At the end of the aisle, the mount hung covered with a large blue tarp. Larry climbed the ladder placed next to it to give a speech and unveil the buck. As he thanked the crowd for coming out, gave praise to Bob the taxidermist, and recounted the story of how the store had acquired and mounted the deer, Hyrum stood by looking around the store from underneath his cowboy hat. He saw the people of his life, his family, friends, students, and neighbors. He needed this.

Larry finished his speech and carefully unveiled the deer. As he did, the crowd gave a collective gasp. The animal dwarfed the mounts on either side. The enormous, regal looking head was turned slightly to the left and held aloft the huge sprawling rack of antlers spanning 42 inches across.

A twinge of guilt rolled through Hyrum's stomach. He felt the tormenting guilt of Judas. He wished he hadn't slain the creature. But there's no redemption without sacrifice. He now understood the paradoxical plight of Judas and felt a great deal of empathy for the maligned man.

Larry had fastened a plaque to the wall below the mount that read in large letters,

Born Again
 'THE KING OF DEERS'
 Below, in smaller letters read,
 'SHOT BY HYRUM JAMES'
 As the people began to cheer, take pictures, and shake Hyrum's hand, he paused and looked up into the creature's large brown eyes. They looked down upon him with a mother's kindness and understanding and told him that all was well.

www.ingramcontent.com/pod-product-compliance
Lightning Source LLC
Chambersburg PA
CBHW072214170526
45158CB00002BA/591